MW00443820

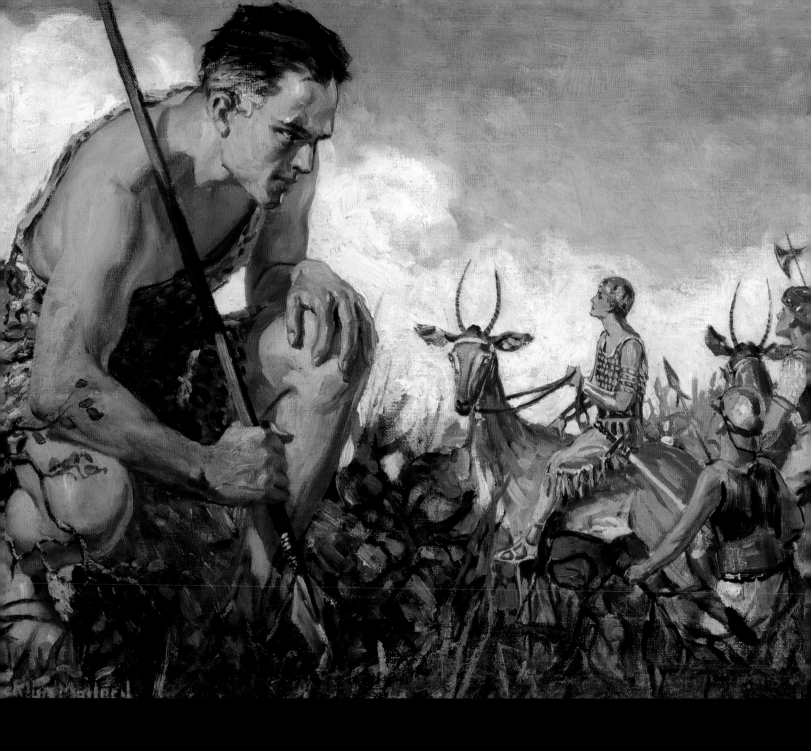

SAVAGE
ART

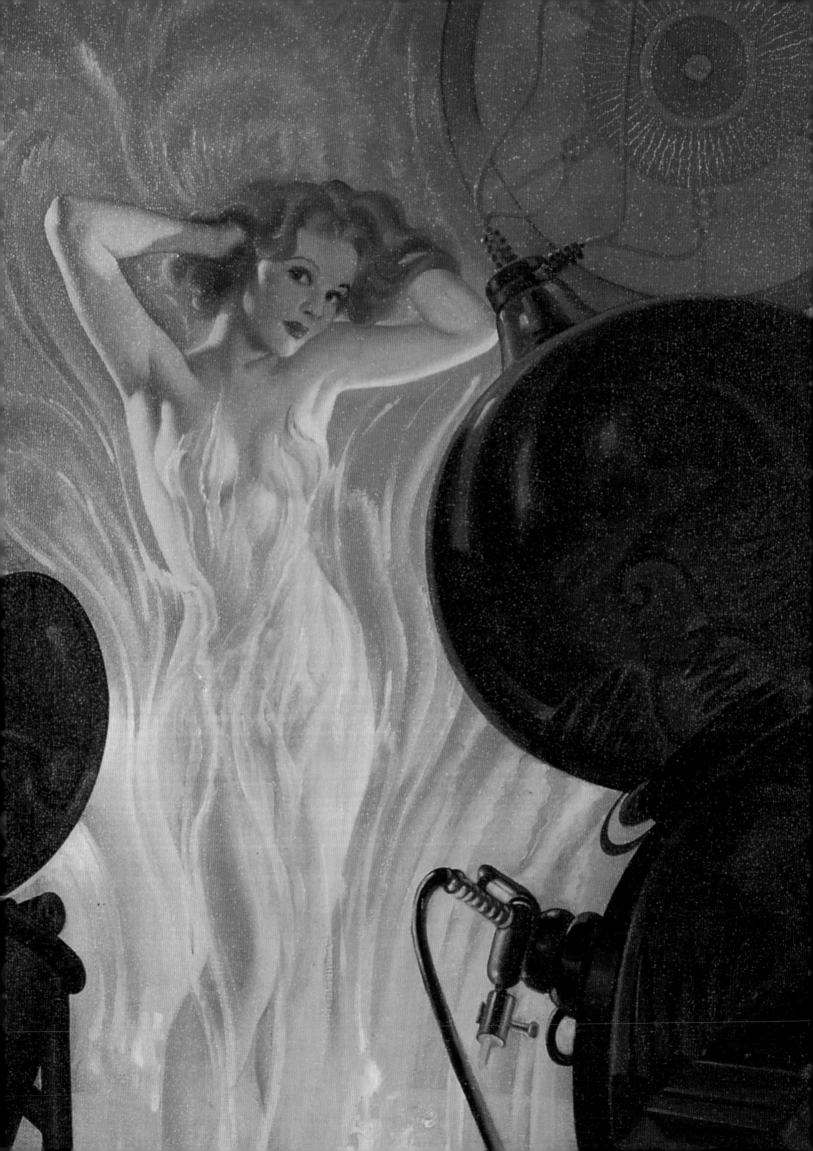

SAVAGE
ART

20th Century Genre
and the Artists That Defined it

Introduction by
Frank M. Robinson

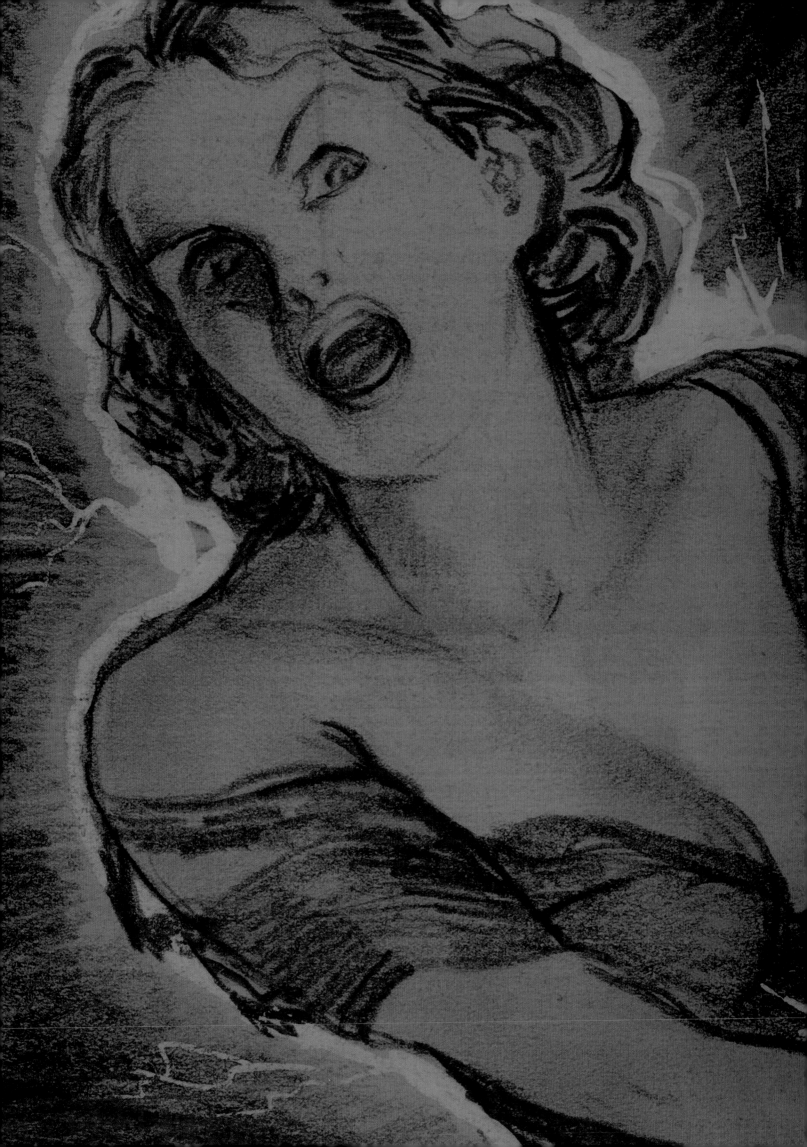

Page 1: Stockton Mulford
Page 2: Harold McCauley
Pages 3-4: Rafael De Soto

ISBN-10: 1599290561
ISBN-13: 978-1599290560

10 9 8 7 6 5 4 3 2 1

PUBLISHED BY
UNDERWOOD BOOKS
P.O. Box 1919, Nevada City, CA 95959
www.underwoodbooks.com
Tim Underwood/*Publisher*

THE VAMPIRE MASTER by Hugh Davidson

PAINT, CANVAS, *ACTION!*

Introduction by Frank M. Robinson

At the turn of the last century, Americans lived primarily in rural areas and small towns. They had no radio, no motion pictures, no television, no computers and no internet. Entertainment consisted of husking bees, chatauquas, the church social, the occasional wandering minstrel show and if you lived in one of the few large cities—say, New York—there were stage plays.

On chill winter nights, few farmers left the house except to milk cows and city dwellers preferred to huddle around the fireplace rather than venture into the cold to catch a horse-drawn cab to the theater.

The major form of entertainment was reading. At one time there were sixteen daily newspapers in New York and there were magazines like *Cosmopolitan, Redbook, American Magazine, Lippincott's, Everybody's, Metropolitan, McClure's,* etc.—all of which were family oriented. Most were dull looking publications, printed on slick paper, which ran blurbs for their contents on the cover and filled the inside with articles, a few short stories or serials, a little poetry, badly printed photographs of plump stage beauties and politicians of the era and pages and pages of ads.

The bright spot of publishing were the "story" papers—eight page broadsheets published every Saturday, a few of which were aimed at the family trade—*The Family Story Paper* and the *New York Ledger,* which boasted a circulation of close to half a million and whose owner was one of the richest men in New York. *The Ledger* published Dickens and Longfellow and was one of the first to publish a review of Walt Whitman's "Leaves of Grass."

For the kids there was *Saturday Night,* Street & Smith's *New York Weekly, Boys of New York* and half a dozen others. The *New York Weekly* published adventure stories and such epics as "One More Unfortunate; or, Nelly, the Newsgirl."

The family story papers were relatively sedate and upscale. The more sensational papers like *The New York Weekly* ran Buffalo Bill and Nick Carter serials and when they ended there were always "Red Dick, the Tiger of California"; "Chipmunk, the Wyandotte"; and "Cinnamon Tom."

The story papers also forecast the cover trends that the pulps in the nineteen-twenties and -thirties would take. The family papers published a relatively small woodcut on their front page—nothing to upset grandma knitting in a corner of the living room. The sensational papers didn't spare the gore. Their cover woodcut took up more than half a page and sometimes a whole page (super size woodcuts were made in sections and joined on the press). The typical front page of *The New York Weekly* might feature a traitorous scout getting shot in the head while Indian accomplices hid behind the trees ("A sharp, ringing crack, then a wild shriek as the leaden missile buried itself in the brain of the villainous decoy.") Other story papers were equally as exciting.

The papers dwindled toward the end of the century but their audience didn't. It switched to dime novels, some of them the size of a thick paperback, while others resembled Golden Age comic books in size (technical term: "nickel books"). The irresistible draw was the "full-length" novel inside and full color covers—something *Cosmopolitan, McClure's* and *Lippincott's* didn't yet have.

The first pulp magazine was dated October, 1896. It didn't compete with the dime novel but with the regular family-oriented magazines such as *Cosmo,* etc. *The Argosy* was the same page size but thicker, printed on wood pulp paper with no illustrations, no photographs, and not even a plug for the contents on the cover. It was cheap—ten cents—and it was devoted to what readers wanted more than anything else: fiction.

Argosy, a companion to *The Munsey,* the publisher's version of the standard family magazine, doubled in circulation the first year and doubled

and redoubled until it was selling 500,000 copies an issue by 1907.

One success deserves another and by 1907 *The Argosy* was joined by *The Railroad Man's Magazine* (primarily articles and some fiction), *The Ocean* (ditto) and in 1905 another all-fiction magazine, *The All-Story*. In 1908, publisher

Frank Munsey added still another: *The Cavalier*.

Other publishers, envious of Munsey's successful gamble, quickly followed with their own titles. Street and Smith came out with *The Popular Magazine* in 1903. Originally aimed at boys, it broadened its appeal when it discovered more men than boys were reading it. S&S added *People's Magazine* in 1906 and *Top Notch* in 1910. *Monthly Story Magazine,*

Bill Weekly became the weekly *Western Story Magazine.*

The age of specialization had begun and the sale of pulp magazines soared. In the '20s more detective magazines appeared, as did more western titles— the last dime novel, *Wild West Weekly*, became a pulp with the same title in 1927. There were "war" magazines (World War I, that is), airplane magazines, sport story magazines, sea story magazines—all soon crowded the newsstands. Little noted was a pulp magazine titled *Weird Tales,* which has become the most sought after magazine by collectors.

Many of the early pulps were simply all-fiction counterparts of the slicks of the period, aimed at a family audience. *Blue Book* featured portraits of

 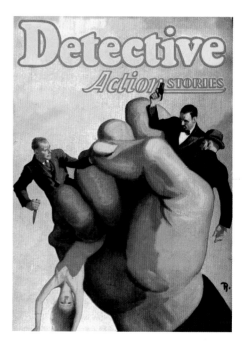

from a rival publisher, appeared in 1905. A family oriented fiction magazine, in addition to its pulp pages *Monthly Story* also carried eight pages of slick paper with photographs of stage plays of the period. Within a year, the magazine changed its title to Blue Book.

Adventure appeared in 1910 and was probably the first specialized pulp. Most of the other pulps carried a glamorous shot of a woman on the cover; *Adventure* knew its audience—it featured pirates. But in their early years, many of the pulps felt their way cautiously, unable to make up their mind whether they were just all fiction replicas of the slicks of the period or something brand new, a linear descendant of the old story papers where bullets "buried themselves within the brain of the villainous decoy." It took a while to sort out their identity.

The flood gates opened in 1915 when Street & Smith changed its dime novel magazine *Nick Carter* to *Detective Story Magazine*. In 1919, *New Buffalo*

women on their front cover for years before figuring out that most of their audience were men. During World War I, *Adventure* feminized its logo and put a pretty woman on the cover to attract a female audience, convinced that most of its male readers had joined the army. Circulation plummeted and within a dozen or so issues, the magazine returned to its old look featuring cowboys and pirates.

Covers for *Western Story* and *Cowboy Stories* were bucolic when the magazines began. The first issue of *Cowboy Stories* in 1925 showed a cowboy herding a bunch of steers under a starry night sky. Early issues of *Western Story* portrayed Indians as they really were—scruffy and defeated, not a rifle or a feather headdress in sight. Over the logo was the line: "Big clean stories of outdoor life."

Street and Smith remembered the past and followed the success of *The Shadow* with more hero pulps like *Doc Savage, The Avenger, Nick Carter* (in a pulp format), *The Skipper, The Whisperer, The Wizard,* etc.

You had to wait until the melee of the 1930's when the "Spicy" pulps (*Spicy Detective, Spicy Adventure, Spicy Mystery*) and the big bad stories finally showed up. For the westerns and the mysteries and the "shudder" pulps of that period, it was down and dirty, the more sensational, the better.

By the 1930's the newsstand racks were groaning. Added to the stew were romance magazines, many more "hero" pulps and the "stroke" books. Despite the Great Depression, pulp publishers were becoming rich. The paper was cheap, printers had open time on their presses so press time was cheap, and many authors were paid only on threat of lawsuit. One estimate had it that for $500, you could start your own magazine. Buy the paper on credit, strike a deal

but many saw no worth in the actual product and once the magazine had been printed, tossed the cover painting in the back alley.

In terms of sales appeal, the pulps were much like modern movies—the covers were the "special effects."

Of those artists who provided the special effects, the most prolific was Norman Saunders, who painted more than 800 covers for close to a hundred pulps—and this isn't counting the work he did for the slicks. After the middle '50s, when the pulps had finally died, he did artwork for paperbacks, comic books and trading cards (the original "Mars Attacks" cards were painted by Saunders).

Saunders' incredible output was due to talent:

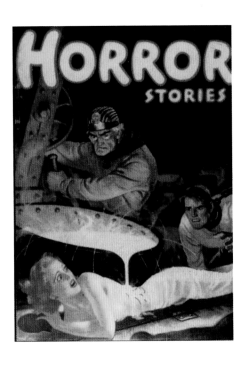 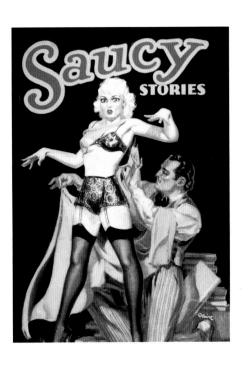

with the printer, and starve your authors—and your artists.

In the face of all this competition, what made a particular magazine sell? Authors played a major role—"Edgar Rice Burroughs" on the cover might add fifteen to twenty percent to the average sale. "Max Brand" was a draw and later, "Robert E. Howard."

And then there were the covers.

Publishers knew the covers had a good deal to do with sales and if readers were torn between two magazines, it was the cover that closed the sale. Years later, these pulps became collectors' items and drew high prices at auctions. If one copy of a rare magazine pulled in a hundred dollars, the original cover art for that issue went for much more: today, a cover painting for which the artist was originally paid a hundred or two hundred dollars might bring in ten thousand or more at auction. But the supply of these original cover paintings is very limited. Publishers valued the image for its impact on sales,

he could paint anything—and do it very well. His specialties ranged from detectives to westerns, from science fiction to the Spicys (for many of the latter he used his middle name of "Blaine"). No pulp artist ever matched the action and sensuality of his cover for *Saucy Movie Tales* showing a high kicker in black net stockings, red cape and little else. (Like some of the other pulp artists, Saunders married the girl who modeled for him.)

Rudolph Belarski didn't match Saunders for output but he came close. He was especially proficient in the air war pulps and he hit almost every Thrilling Publications title, from *Thrilling Adventures* to *Thrilling Wonder Stories*. He painted his share of western and mystery pulps and after the pulps had coughed their last, painted covers for the men's adventure magazines such as *Man's Conquest* and *Stag* and the slick versions of *Argosy* and *Adventure*. (For the most part, the stories in the "true" men's adventures magazines were fiction. Belarski had to do little research for them—he'd already done it a

hundred times.)

Walter Baumhofer started his career with a handicap few other artists suffered—he'd blown three fingers off his left hand while handling live ammunition. But the handicap didn't prove to be much of a hindrance. Baumhofer started his art career drawing interiors for *Adventure* magazine and a few years later hit *Danger Trail* with his first color cover. He was a master of character and created the "look" of Doc Savage when he painted the covers for the first forty-three issues. He also painted all the covers for Pete Rice, the first western hero pulp (some might argue that Billy West of *Wild West Weekly* was the first). Baumhofer's first cover for *Western Story Magazine* showing a lawman (rustler?) in yellow trench coat and red mask holding a rifle, all against a pure black background, was a showstopper. During the late '30s, Baumhofer did some work for the slicks and after the pulps died, worked for the more upscale men's adventure magazines, including *Outdoor Life*, *Sports Afield* and *True*.

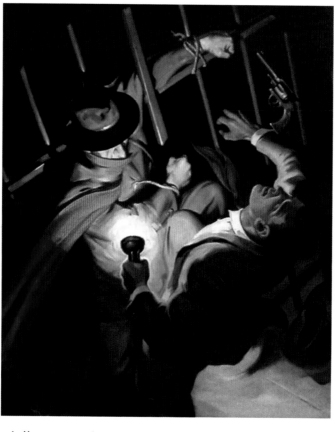

Rafael de Soto was another big producer when it came to painting pulp covers and he managed to paint for all the genres. He was especially strong in mystery and detective, painting covers for *The Spider* and *Ace Sports* and covers for both *Famous Fantastic Mysteries* as well as *Fantastic Novels*. One of his best cover paintings (for *War Stories*), surprising for a pulp artist, showed a soldier holding up his wounded buddy and shouting for help. It was an emotional commentary on war that probably shocked most readers. Unlike most war covers, it wasn't a recruiting poster... Like many of his prolific compatriots, de Soto worked for the slicks upon occasion and after the pulps died made a comfortable living painting paperback covers.

An artist who occasionally doubled in brass as a writer, Curtis Delano made the rounds of most of the genres and was fairly prolific in westerns and the general pulps. In 1933 he moved to Arizona but continued to paint pulp covers and occasionally hit the slicks. He loved the West and sold his western paintings through local galleries.

Tom Lovell painted many covers for the "gang" magazines, as well as detective and western. His talents transcended the pulps, however—he sold to the slicks and painted a number of canvases about western oil exploration plus a historical series for the *National Geographic*.

George and Jerome Rozen were twins who traded off painting covers for one of the most famous pulp magazines of them all, *The Shadow*. Jerome painted the first four covers in the series, then George took over and became the definitive artist for the magazine. He also painted a number of western covers and when the pulps died, painted covers for paperbacks. Jerome hit the slicks and did some advertising work but also found time to paint covers for *Over the Top, Excitement, The Mysterious Wu Fang*, and *Dr. Yen Sin* among others.

Graves Gladney was a cover workhorse who started freelancing with sales to *Lariat Story Magazine, Adventure, Dime Mystery* and others. He soon settled in at S&S painting covers for almost all their titles, including *Astounding, Clues, Sport Story* and especially *The Shadow*, for which he painted seventy covers. Unlike some other pulp artists who were too old or 4F for World War II, Gladney went into the service in 1942, landed at Normandy on D-Day and as a first lieutenant led his division into Berlin in 1945. Gladney died rich—his father had been one of the founders of the 7-Up company.

Laurence Herndon was an old-timer (born in 1880) who sold to the early slicks and then to pulps from 1918 on. His primary markets were *Argosy, Blue Book* and many of the Street & Smith titles. He once painted covers for more than twenty-four consecutive issues of *Blue Book*—all of which featured Edgar Rice Burroughs on the cover.

Remington Schuyler was another old-timer who started selling to the *Saturday Evening Post* when he was twenty-two. He painted numerous covers for *Boy's Life* as well as for pulps in the late twenties and early thirties. He became an authority on native American Indians, of immense help when he painted covers for *The Frontier* and *West*.

Gayle Hoskins was a cover painter with the best

pedigree when it came to the pulp business. He studied under Howard Pyle and Frank Schoonover, both creditable book illustrators, and was published by *Redbook* in 1907—he was twenty at the time. By 1918 he was a regular in the slicks. Hoskins became an instructor at an art academy in Wilmington and an honored member of the local Sketch club and the Society of Fine Arts. N. C. Wyeth was best man at his wedding.

Hoskins' life changed in 1929 when he was wiped out in the stock market crash. The slicks did badly during the Great Depression so Hoskins turned to the pulps. He specialized primarily in western covers and may have created the first graphic novel—in 1931 he painted a story in twenty-four consecutive covers for *Western Story Magazine.*

Some of the pulp artists became proficient in "good girl" art, specializing in attractive women, clothed and unclothed. H. J. Ward, best known for painting half naked women, also painted credible western covers (witness *The Lone Ranger* magazine). But his main gig? Star cover artist for the Spicy magazines (as was Norman Saunders for the Saucy's). You'd never introduce a Ward cover girl to your mother—though you might hide her under the bed.

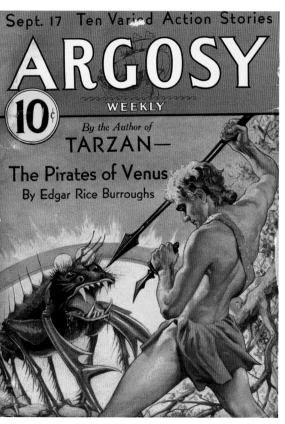

While Ward made a living specializing in sexpots, Harold McCauley painted starlets. He was a staff artist for the Ziff Davis chain (*Amazing Stories, Fantastic Adventures, Mammoth Detective*) and also painted many of the early covers for Bill Hamling's *Imaginative Tales* (as well as interiors for Hamling's *Rogue*, a thin imitation of *Playboy*). He studied under J. Allen St. John who taught at Chicago's Art Institute and the American Academy of Art but picked up much of his skill with an air brush working for Haddon "Sunny" Sundblom—the creator of Coca Cola's iconic Santa Claus. McCauley later did advertising art for Pepsi Cola and Schlitz beer as well as pin-ups and calendar art. Occasionally Ziff-Davis wanted a combination cover of a robot and a girl (or similar subject matter) and Robert Fugua, a member of the Ziff-Davis technical art department, would paint the robot while McCauley supplied the girl. (Ziff-Davis's technical magazines were *Radio News, Popular Photography* and *Popular Aviation*—their pulps were strictly a sideline).

Probably the most beloved and admired of all the pulp artists was J. Allen St. John. Still another old-timer, he started illustrating covers for books in 1912 for A. C. McClurg, a book publisher in his hometown of Chicago. His first Burroughs book was *The Return of Tarzan*—the second book in what was to become a phenomenal series. (The original version of *Tarzan of the Apes* appeared complete in *Munsey's All-Story* for October of 1912. For reasons largely unknown, the editor rejected the sequel. The novel subsequently appeared in Street & Smith's *New Story* magazine, whose editor was delighted to get the story and gave Burroughs a raise).

St. John later painted many covers for *Blue Book,* also published in Chicago at the time. The only painting for a magazine that St. John did of Tarzan was for the January, 1928, issue, the second installment of "Tarzan, Lord of the Jungle."

St. John was later to do some covers for *Weird Tales*—another Chicago publication—and with the October, 1940, issue of *Fantastic Adventures* returned to one of his favorite themes, painting a cave man on the back of a tyrannosaur shooting arrows at a pterodactyl. Originally scheduled to be discontinued with that issue, *Fantastic Adventures* suddenly doubled its circulation—readers hadn't bought the issue for the story, they'd bought it because of the cover. Within a few issues, and more covers by St. John, the magazine became a popular monthly.

It could be argued whether Burroughs had made St. John or whether St. John's evocative covers of life on Mars and Venus and in the center of the Earth with primitive men wearing animal skin Speedos and fighting dinosaurs had made Burroughs. St. John was the inspiration for Frank Frazetta and other paperback adventure illustrators.

Sex hardly played a part in most of the fiction published by the pulps, and only occasionally did you glimpse it on the covers. But Enoch Bolles, H. J. Ward and Margaret Brundage (of all people) institutionalized it. Bolles was a classic illustrator for *Breezy Stories,* usually with the cover girl in a classic pose with just enough clothing to get past the postal inspectors. In addition to magazines, Bolles also did calendar art—the kind you used to

see in barber shops. The point was to encourage you to come back again for a shave and a haircut and a glimpse of the Bolles model for the new month. (Bolles' other personality painted ads for Sun-Maid raisins and Zippo lighters.)

Margaret Brundage's career in the pulps was one of the oddest of them all. She was pretty much limited to one publishing house, painting sixty-six covers for *Weird Tales* and its companion magazines, *Magic Carpet* and *Oriental Stories* and one for *Golden Fleece,* from a different Chicago publisher. And that was all, folks. Her nudity was in-your-face with only a wisp of hair and a strip of cloth hiding the nipples on her well-exposed breasts. The cover formula was simple—a bondage scene featuring a girl in chains being menaced by a masked man with a whip, or by cobras gathered around her, and in one definitely daring painting for the period, a girl crouched against a bush while a black man in a loin cloth whipped her.

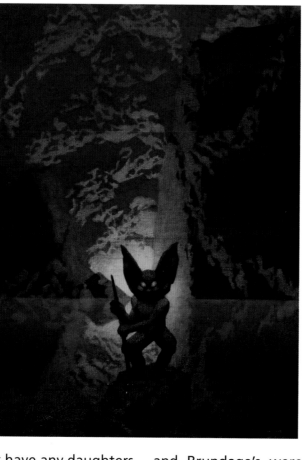

Apparently she got away with it because there was nothing in the magazine that justified the girl on the cover (aside from the publisher's wish to sell it). Brundage was reported to use her daughters as models, but that turned out to be untrue—Brundage didn't have any daughters. Despite Brundage's limited appearances, or perhaps because of them, her paintings are highly collectable.

Three of the most popular pulp artists were also stylists of the first rank, not to be compared to any of the others. Edd Cartier was primarily a black-and-white artist who sold his first interior illustration to *The Shadow* when he was twenty-one and became its primary interior illustrator for years, turning out some eight hundred illustrations for it. His illustrations, pretty "straight" at first became slightly more "cartoon" with time and he gradually slipped into the fantastic, painting covers for *Unknown, Astounding* and an Unknown Annual.

Cartier did three covers for *Unknown,* all of them spectacular. One collector who has one of the *Unknown* covers paid a reported $50,000 for it. (Cartier was paid $8 an interior drawing when he started with *The Shadow*). Toward the end of his life, Cartier sent out an annual Christmas card on which he'd drawn one of his elfin creations. They're collectors items, too.

Grace note: Cartier also illustrated stories about "Fuzzies" for *Other Worlds.* The Fuzzies looked very much like bears—the Ewoks in the third "Star Wars" film are a dead ringer.

Virgil Finlay was another stylist, with a stipple and cross-hatch technique that was immensely tedious to accomplish but beautiful and intriguing to look at. Unbelievably, his originals were the same size as their reproductions but lost a good detail of their detail when printed at high speeds on the rough, high bulk newsprint paper used by the pulps. Flexible as well as talented, Finlay was featured in more magazines than Cartier, even though his output wasn't as great. He had a flair for fantasy and worked extensively for *Weird Tales, Famous Fantastic Mysteries, Fantastic Novels* and the occasional science fiction magazine as well as *Argosy.* He struck it rich when he was commissioned to do illustrations for the *American Weekly,* the largest newspaper Sunday supplement. Finlay also painted an occasional nude but while Bolles and H. J. Ward's nudes were sexy, McCauley's verged on the youthful fashion model, and Brundage's were simply stark, probably the most beautiful nude created for a pulp magazine was by Finlay (cover illustration for Merritt's "Creep, Shadow!") in a 1942 issue of *Famous Fantastic Mysteries.*

The most star-crossed of the stylists was Hannes Bok. Unfortunately, his style—totally unlike that of any other pulp artist—limited the number of his possible markets. He loved fantasy and the characters in his black-and-white illustrations looked like they were carved in granite. They were beautiful to look at but for pulp mavens they were essentially...cold. His color work was more commercial, his jackets for Shasta Books were bright and frequently stunning.

Unfortunately there weren't that many book publishers looking for a talent like Bok's and his magazine markets were limited and low paying. Described as "elfin" by his friends when he was younger, age gradually leached away that quality.

He was disappointed in his markets and distrustful

of the fans who came to idolize him and snoop through his personal belongings. Like Finley in his later years he became fascinated by astrology and probably comforted by the occult. Real life had gradually become hand-to-mouth.

Once the pulps died, so did most of Finley's markets. Virgil Finlay died at fifty-six of cancer. Hannes Bok died at sixty-four, having literally starved himself to death.

Street & Smith dropped their pulps in 1949, with the sole exception of *Astounding,* a digest-sized magazine. With a circulation of a hundred thousand it was described by editor John W. Campbell as a "small goldmine." The last three issues of *The Shadow* and *Doc Savage,* both having been digests for years, reverted to a standard pulp-size format with covers by some of their old-time artists for one last try for sales. It didn't work and after some forty-five years, Street & Smith bowed out of the pulp field for good.

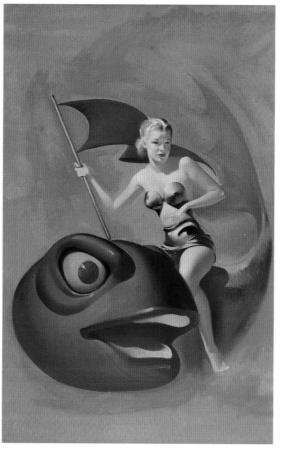

The major chains of Thrilling and Popular held out for a few more years but by the mid-fifties, it was all over. There were digest-sized all-fiction magazines, a lot of them, mostly science fiction and mysteries, but there were no more pulps.

The pulp artists fled into different lines of work. Hubert Rogers, a Canadian who worked primarily for *Adventure* and made the future come alive on the covers of *Astounding,* became a portrait painter. Some, like Nick Eggenhofer a cover artist for the westerns, actually went out West and painted western landscapes and portraits for art galleries.

John Newton Howitt, who had painted seventy-one covers for *The Spider* and forty-seven for *Operator #5,* was also the chief artist for *Horror Stories* and *Terror Tales,* magazines he detested. He signed the covers with a simple "H" rather than his full name and one summer day took all his paintings into the back yard and threw them in a bonfire.

The more prolific artists who had serviced a number of different pulps and had done work for the slicks and paperbacks simply retired.

The writers scattered to the four winds, some of them writing paperbacks and working for the comics, a lot of them drifting into television which had a desperate need for stories and people who knew how to write them. Among them were Roy Huggins, who had written for *Mammoth Detective* and *Mammoth Mystery,* and in Hollywood worked for *77 Sunset Strip* and *The Rockford Files.* A protégé of Howard Browne he later brought Browne out to help. Robert Leslie Bellem—whose detectives never carried guns but "gats" and "roscoes" that never fired but "barked", and whose heroines were women with "creamy-white thighs"—also found a berth writing scripts for *77 Sunset Strip* and *Perry Mason,* among others.

Elmore Leonard, who had written westerns for the pulps, turned to writing mystery books, a number of which were made into films. Louis L'Amour had worked for the aviation pulps and now turned to writing western books which became bestsellers.

A story is a story is a story, no matter what the format.

The pulps left behind a legacy of writers who knew how to tell a story and artists who showed film directors what the stories should look like. Embryo screenwriters and art directors used to haunt Collectors Bookstore in Hollywood to pick through the old pulps on sale there to find out how it was done.

There's a reason why Hollywood does so many remakes of old successful movies. Read reviews for both new TV shows and current films: the most frequent complaint is that the story doesn't make sense. Or worse, that there isn't one.

A lot of the pulps weren't top notch—but when they were good, they were *very* good. They gave us Tarzan and Captain Hornblower and Dr. Kildare and the Continental Op (Dashiell Hammett) and stories by Raymond Chandler and Ray Bradbury, among a host of others.

All gone now, and only the echoes left behind.

When you're entranced by the special effects that sell movies, including the latest 3D film which may gross a billion dollars, just remember some things haven't changed: once upon a time it was primarily the covers that sold the pulps.

When it comes to entertainment, it's still a visual world out there—and it always will be.

—*Frank M. Robinson*

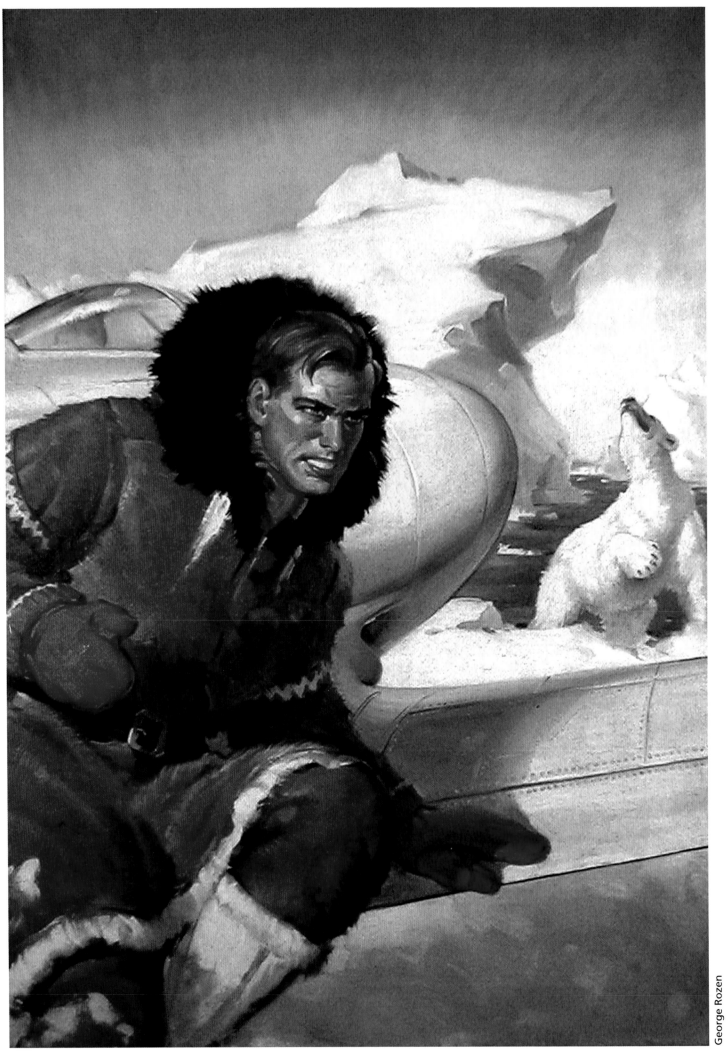

George Rozen

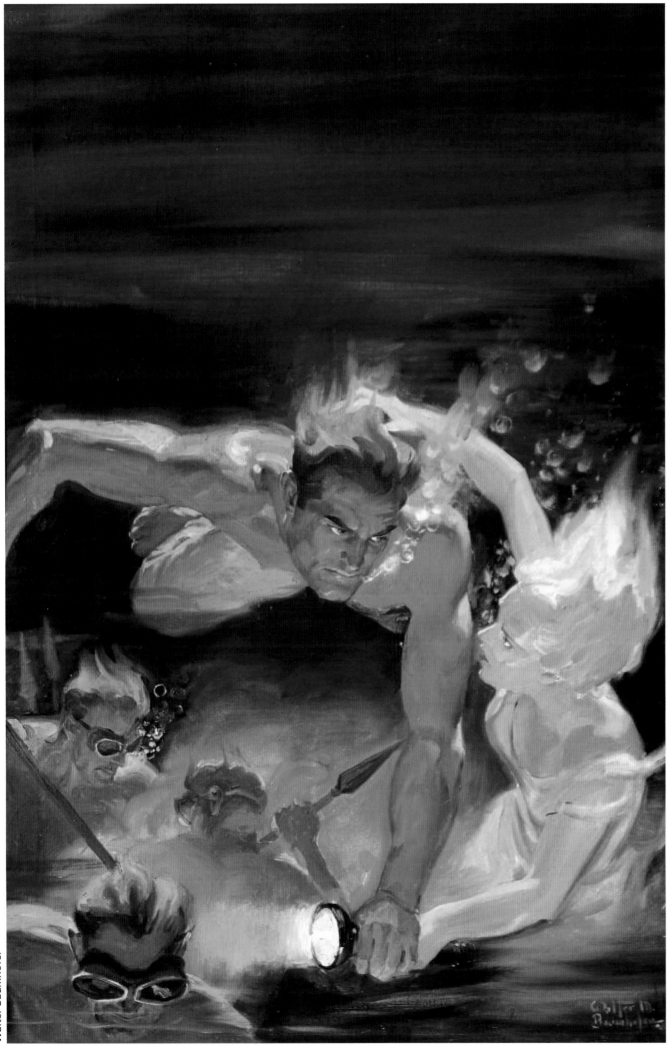

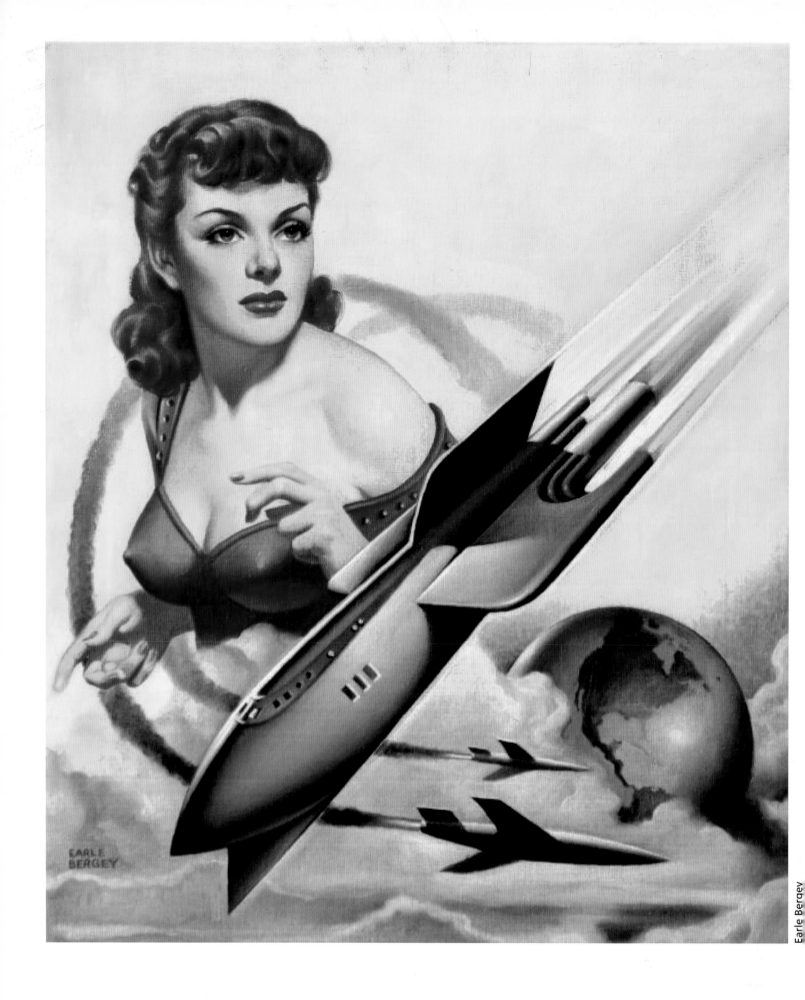

Earle Bergey

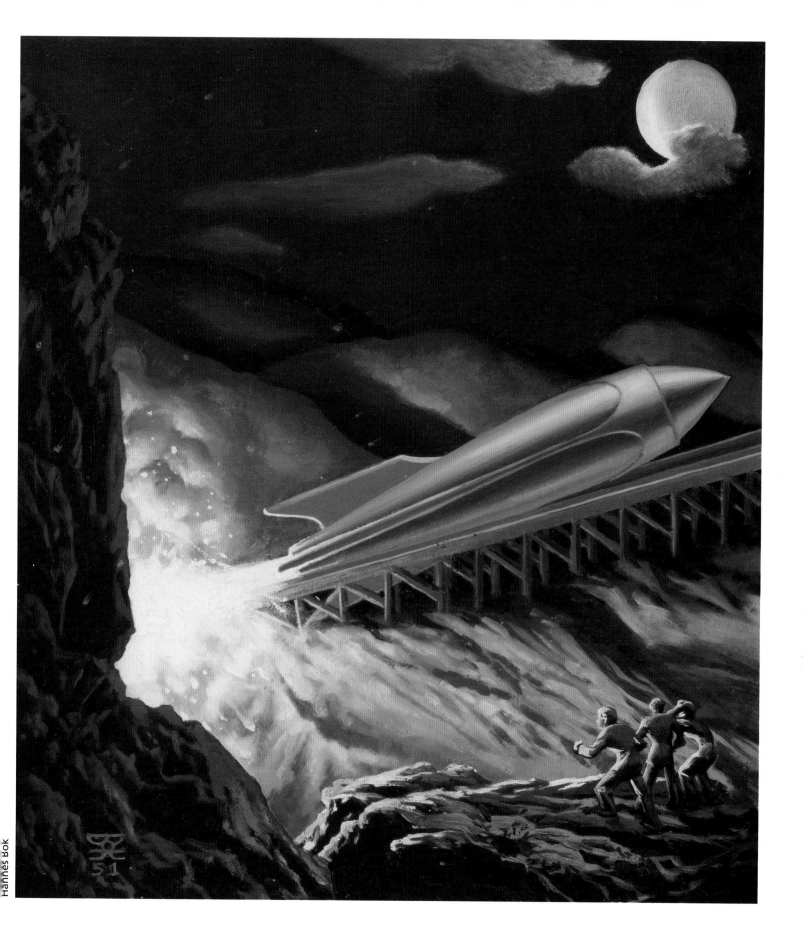

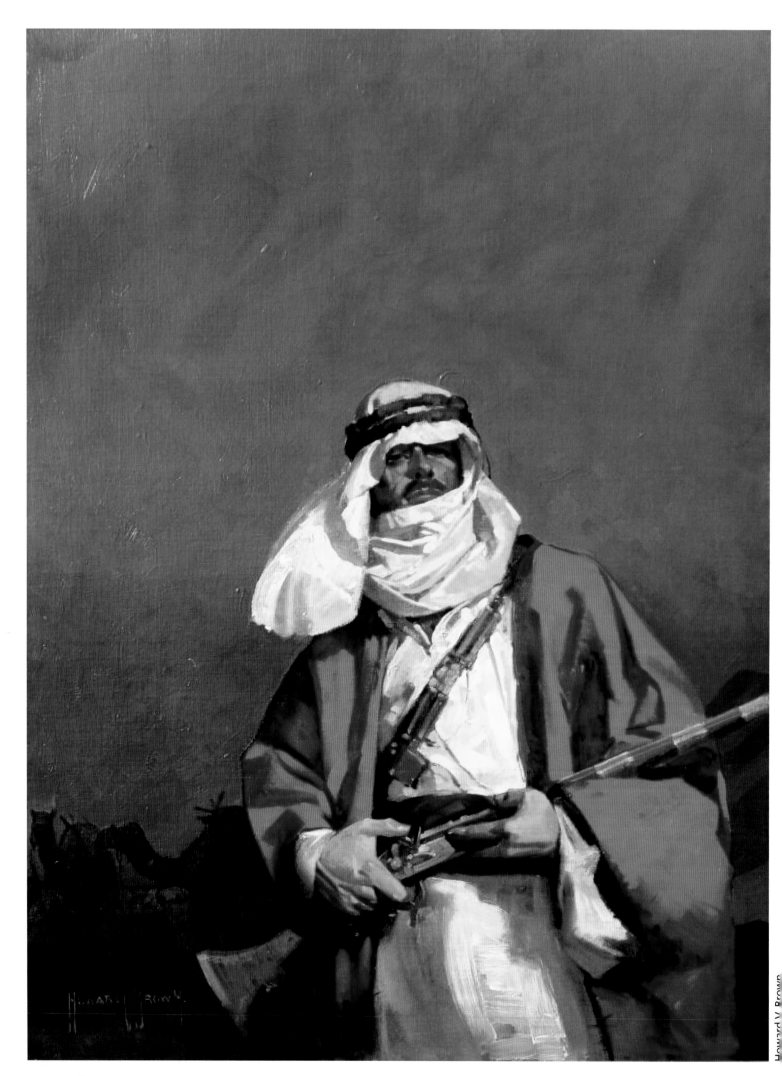

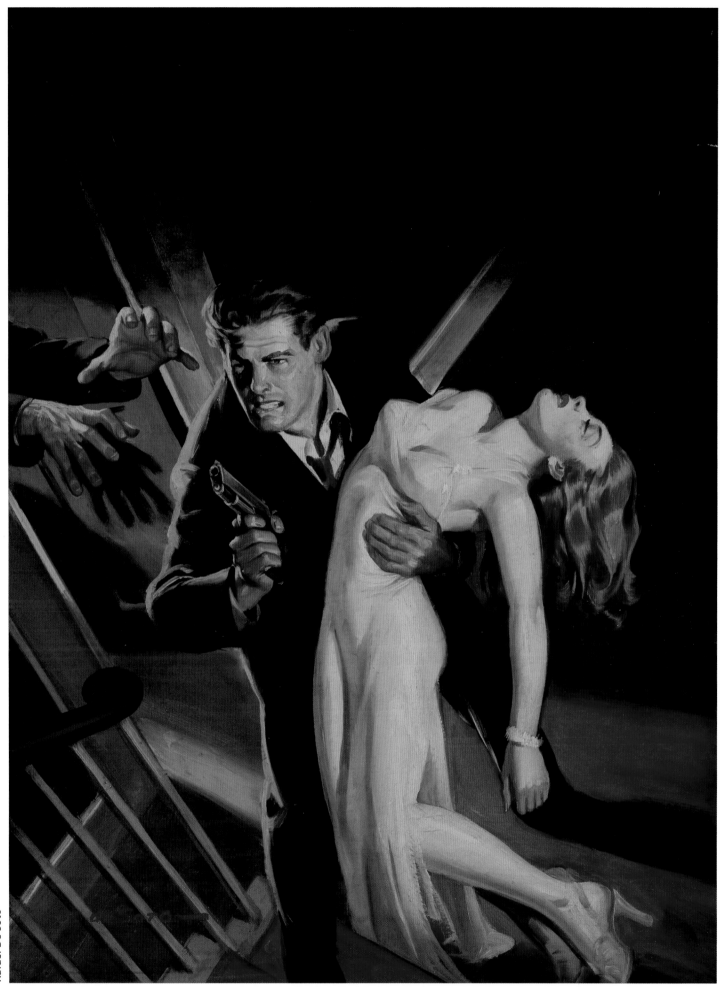

Rafael De Soto

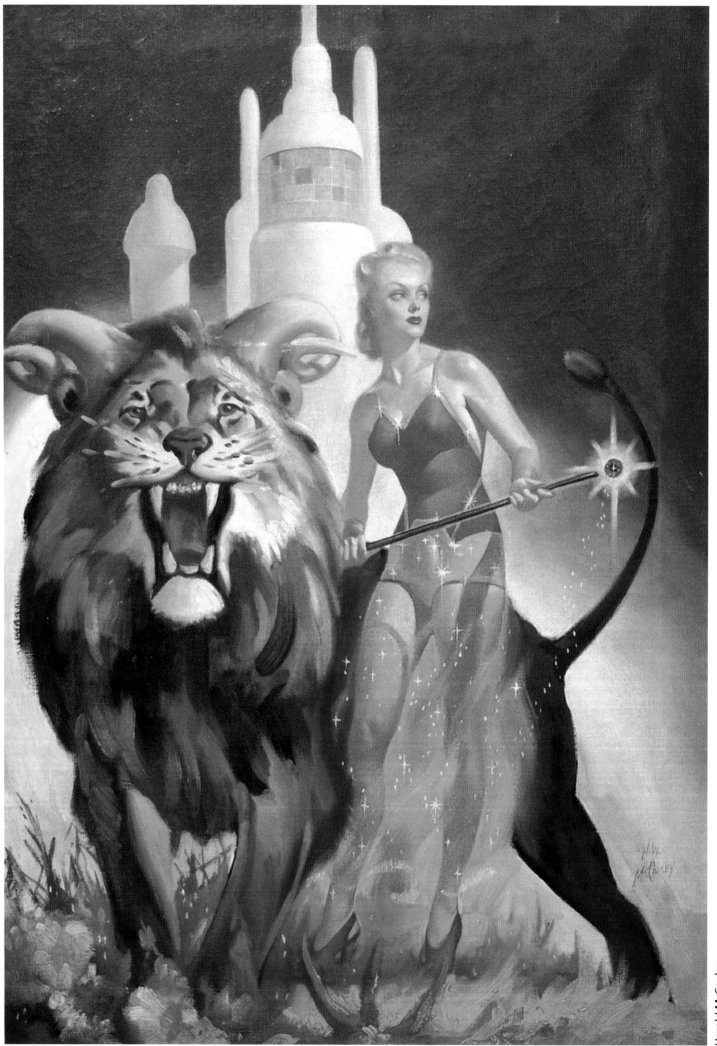

Harold McCauley

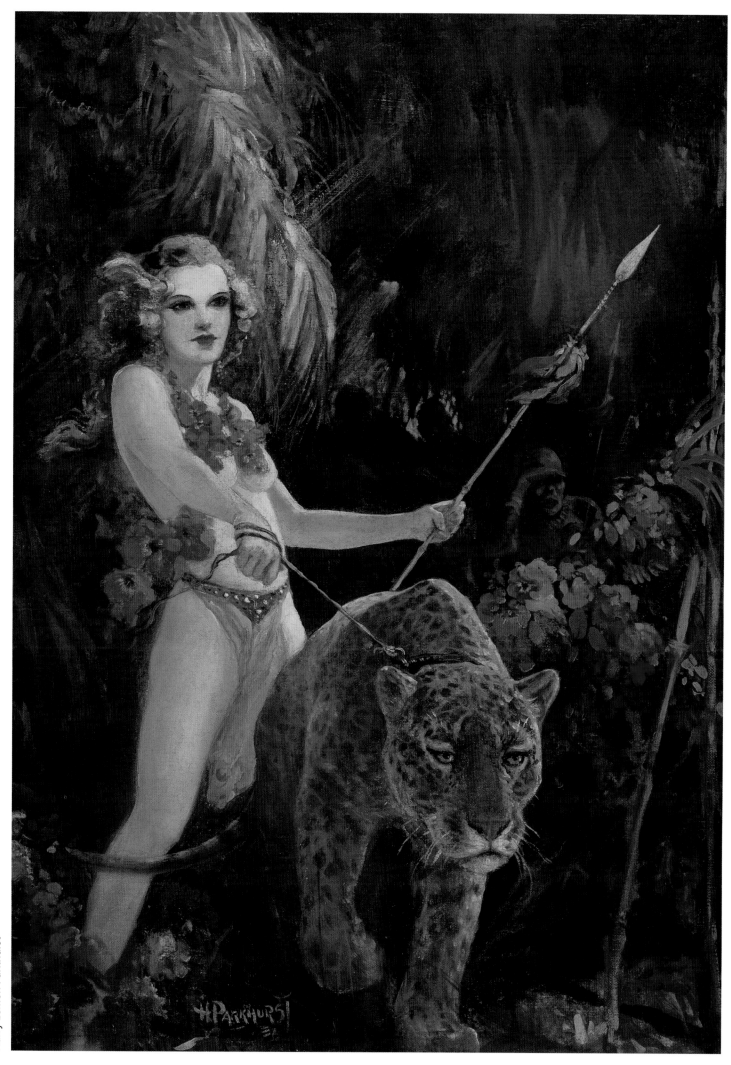

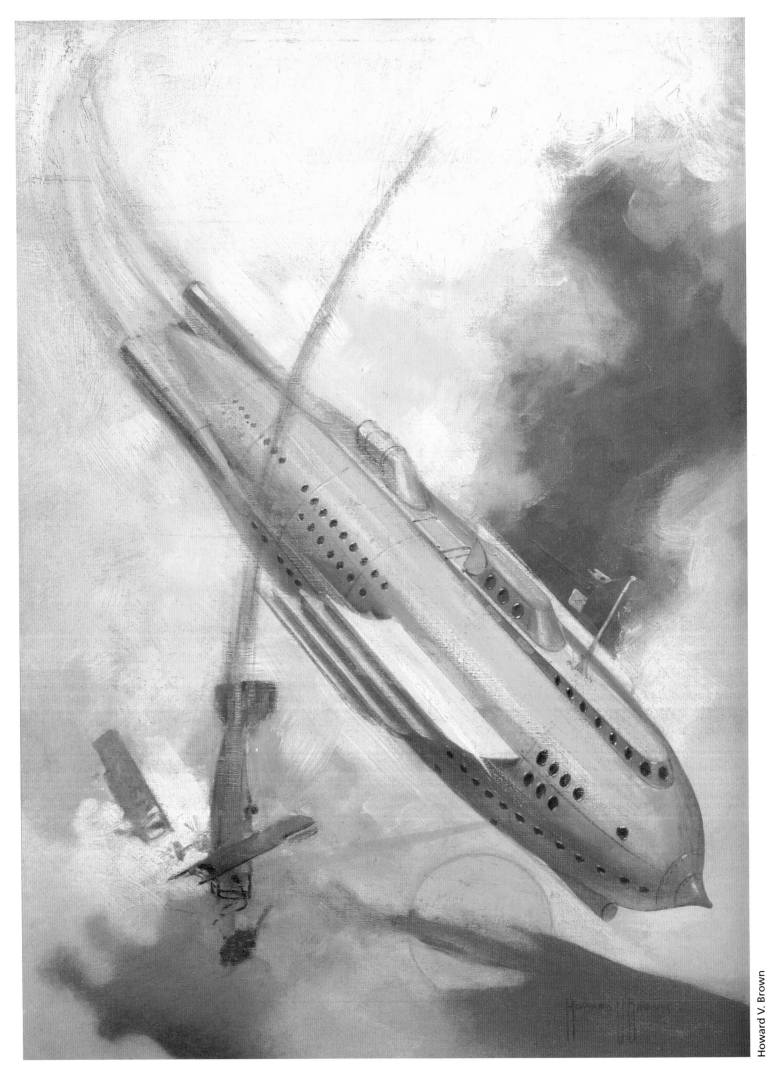

Howard V. Brown

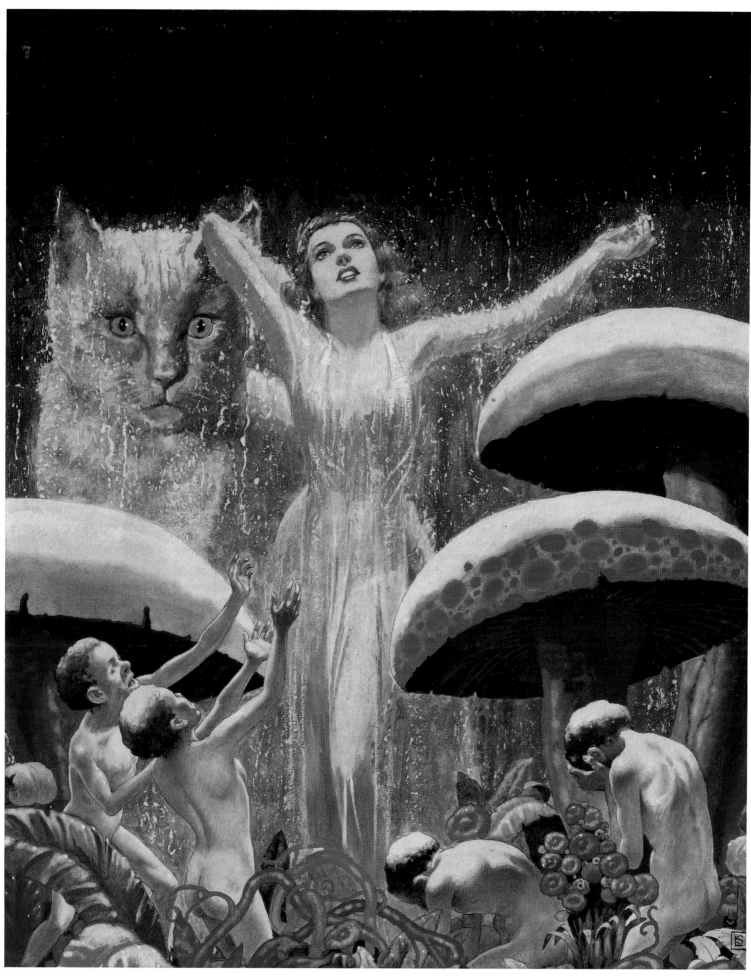

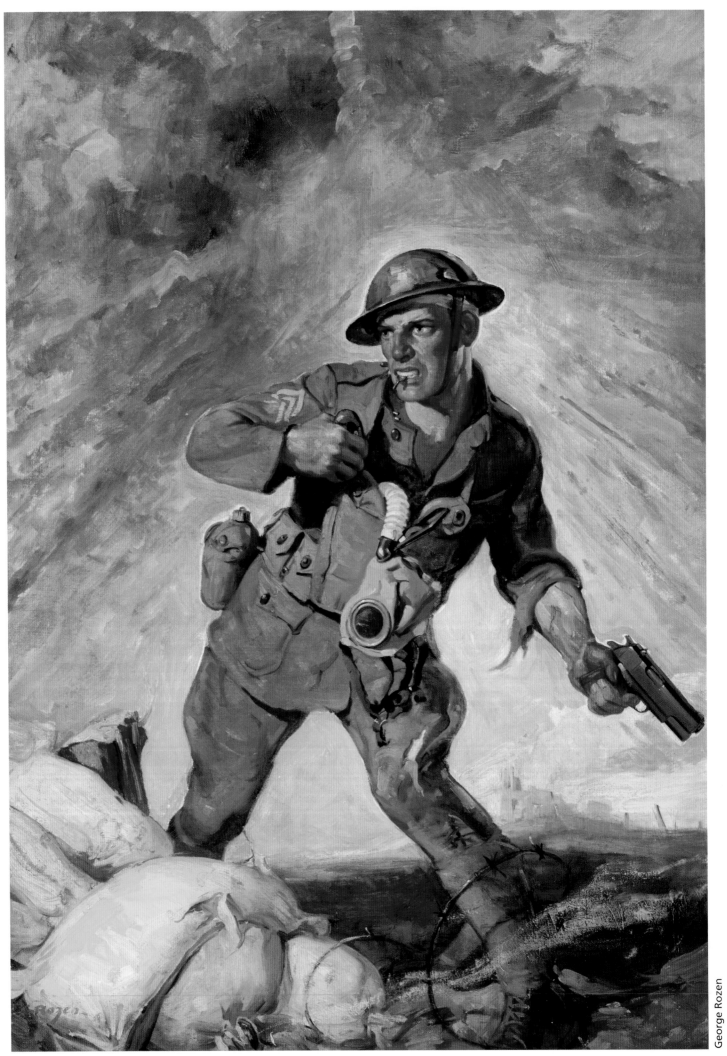

SAVAGE ART

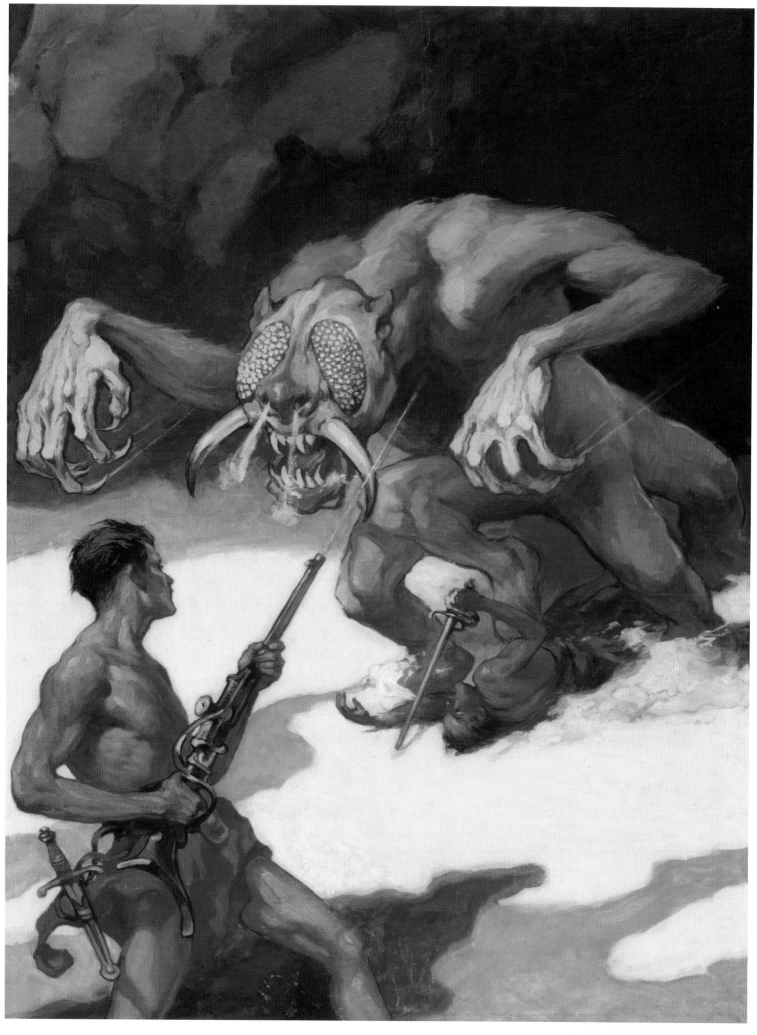

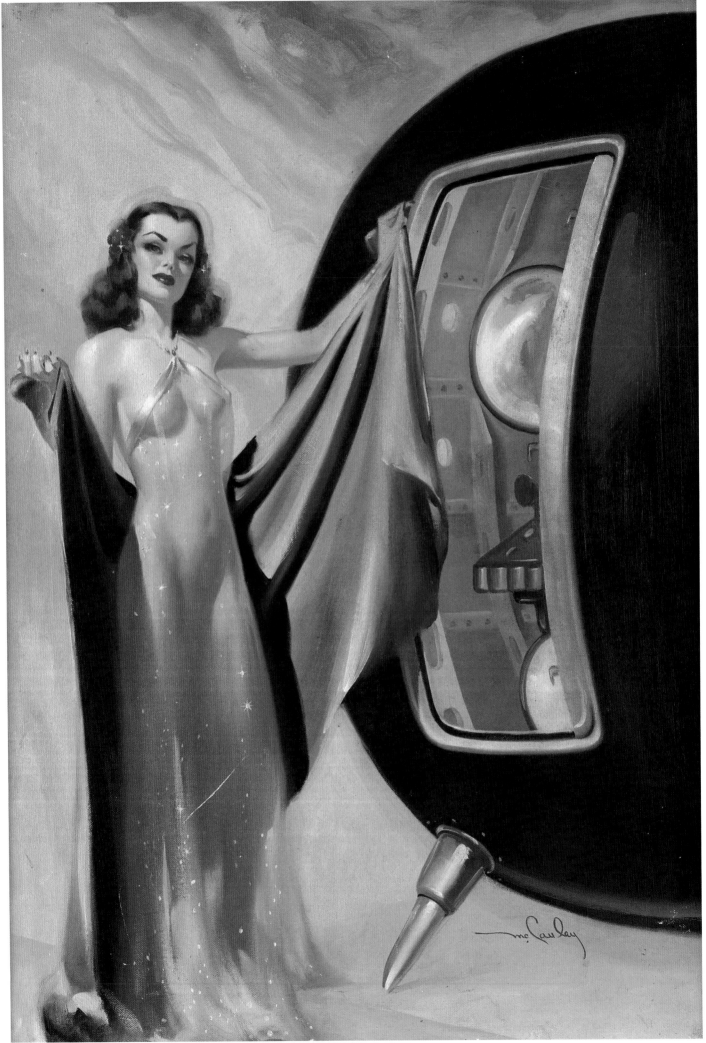

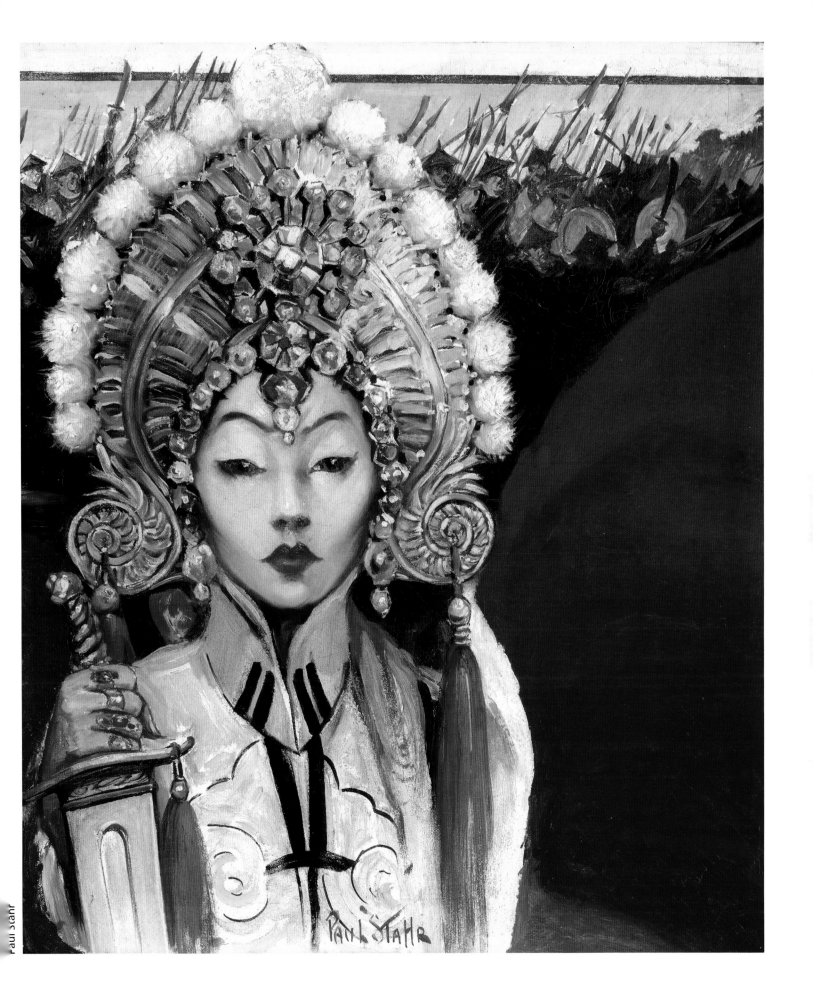

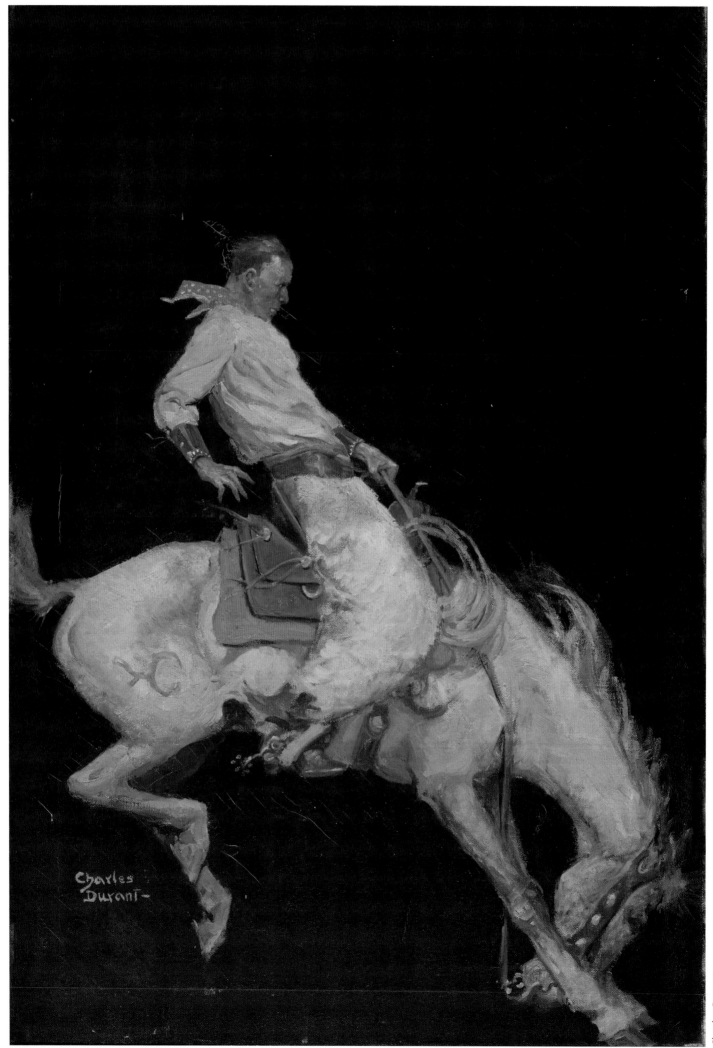

Charles Durant

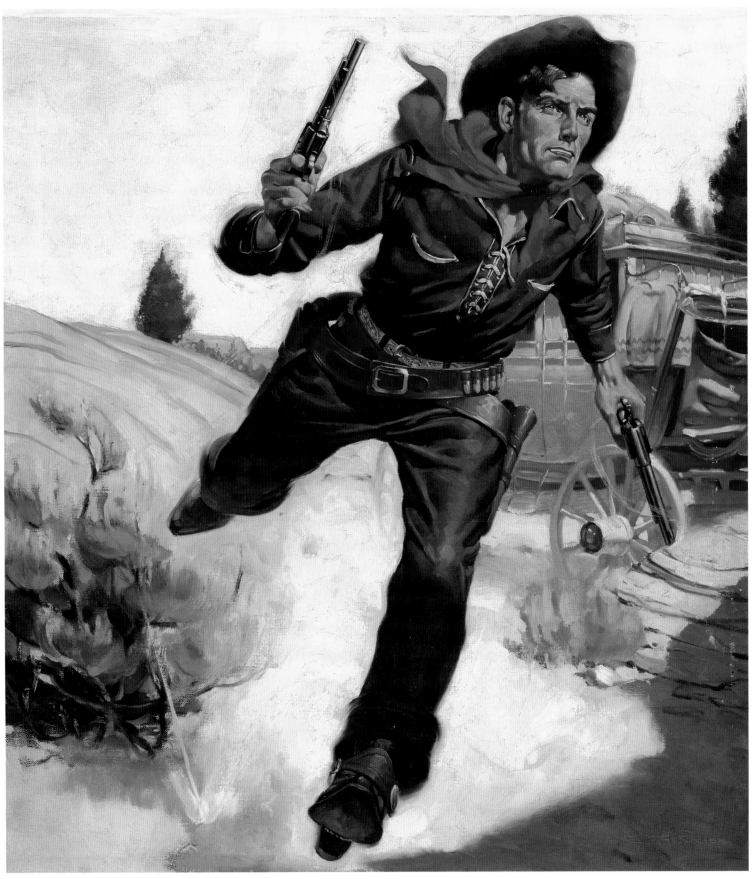

Robert G. Harris

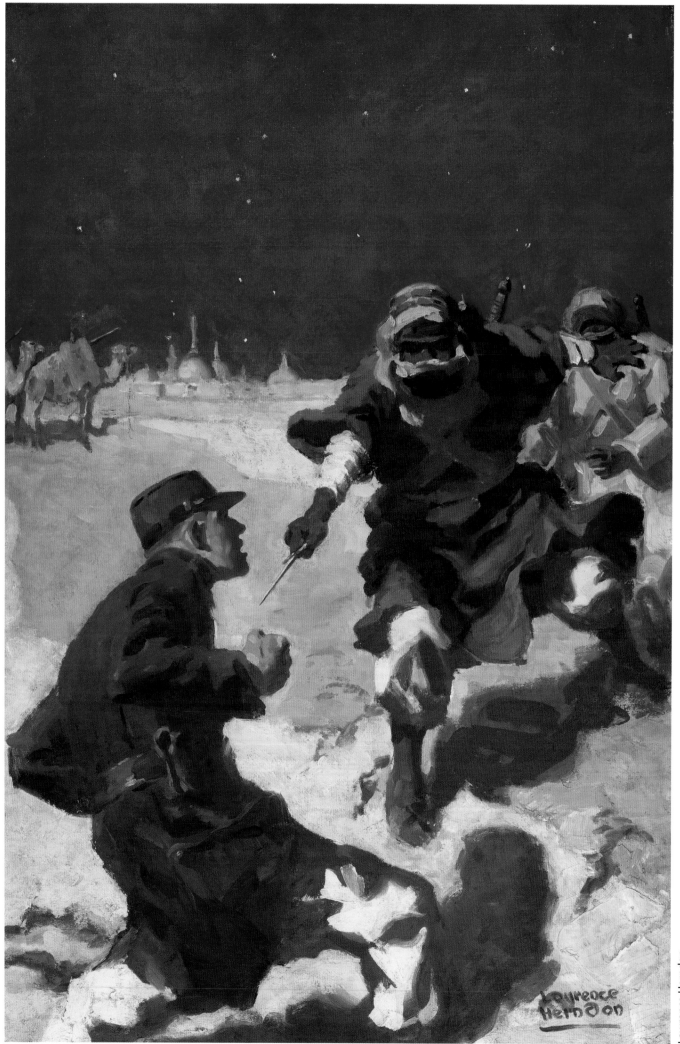

Lawrence Herndon

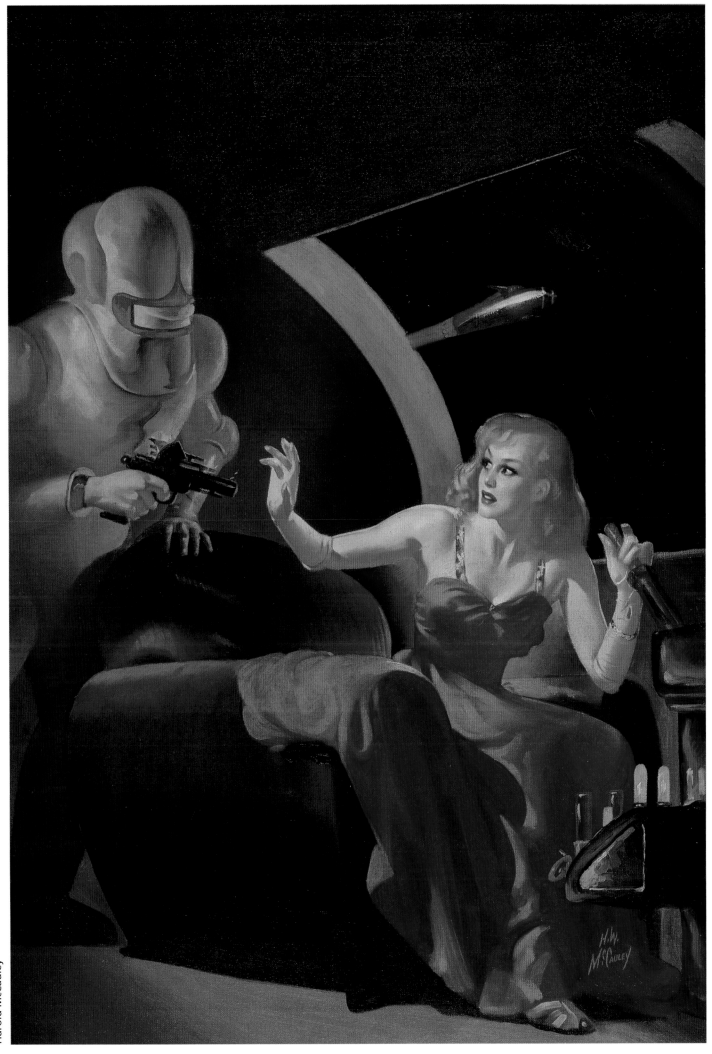

Harold McCauley

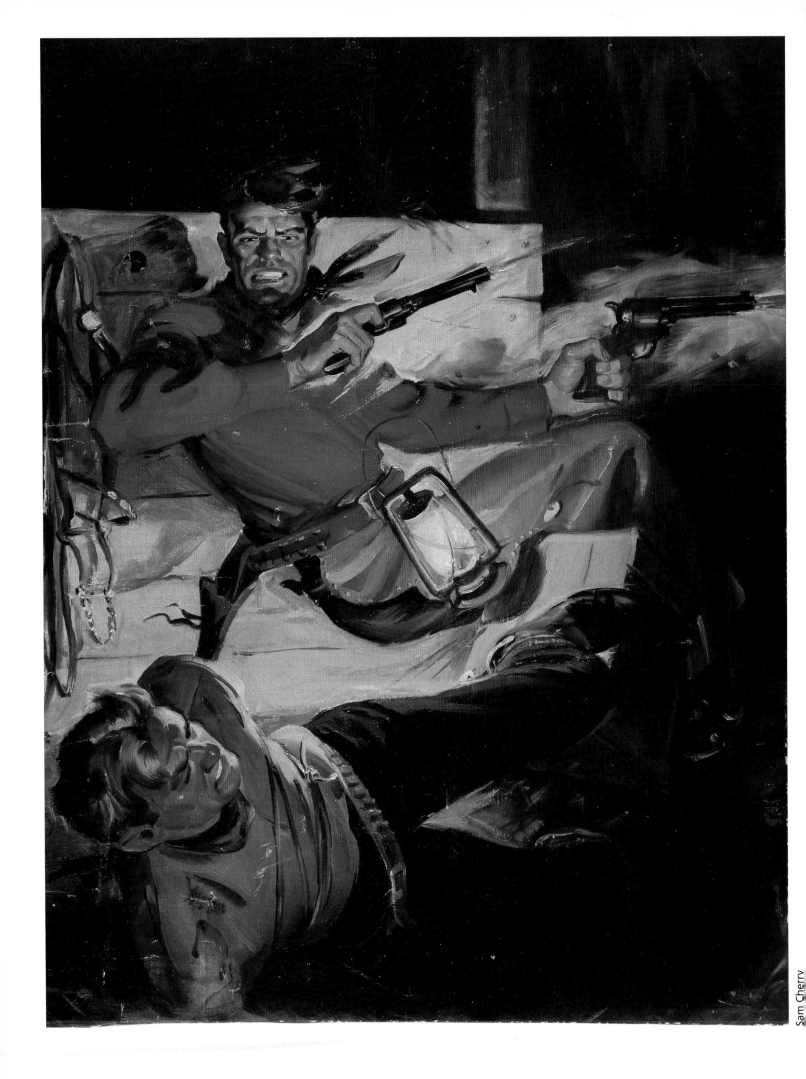

Sam Cherry

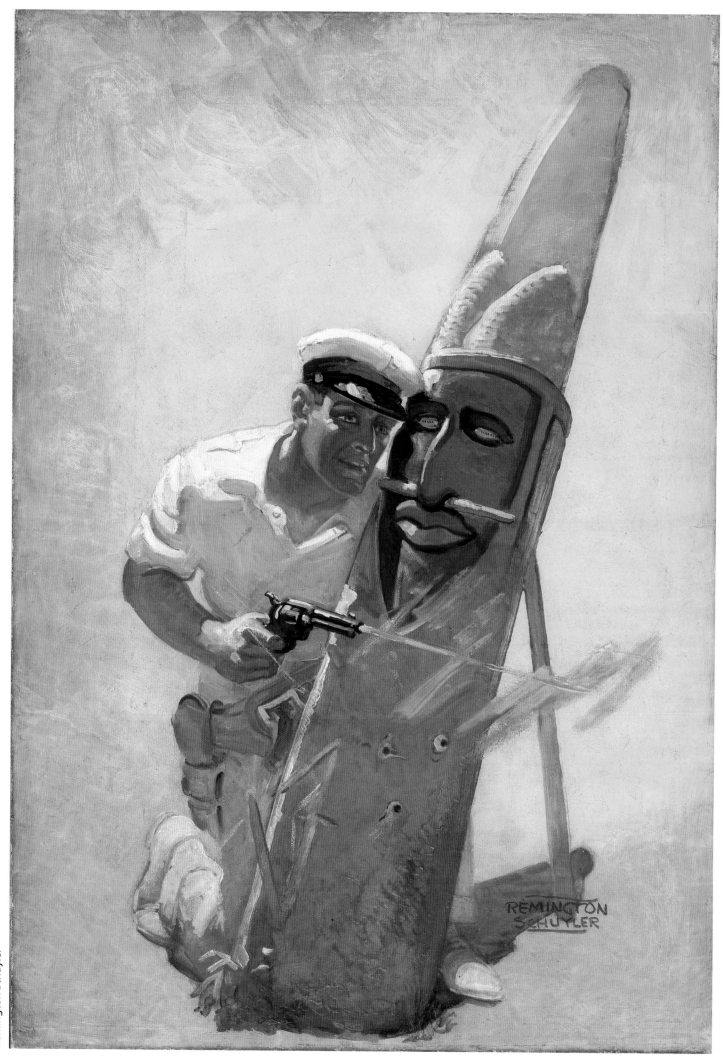

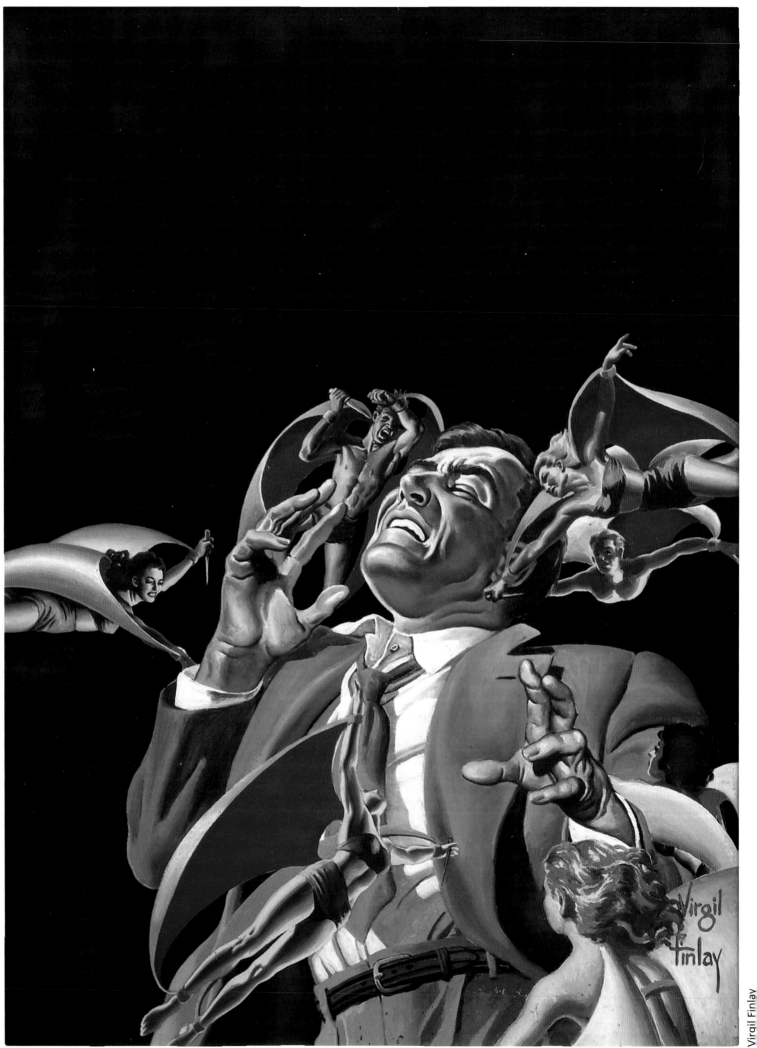

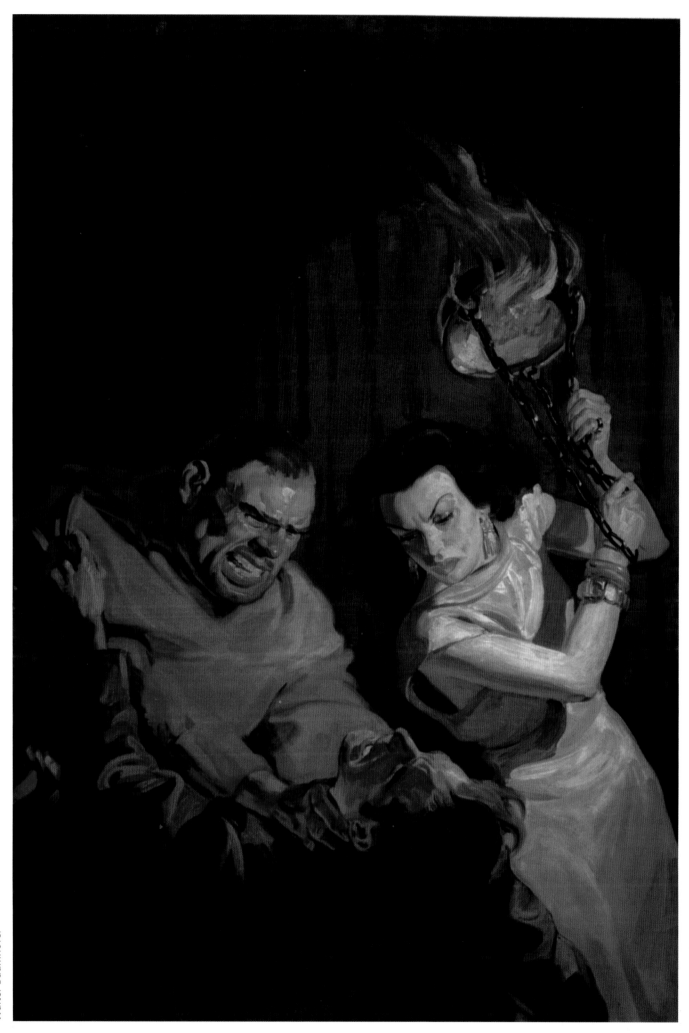

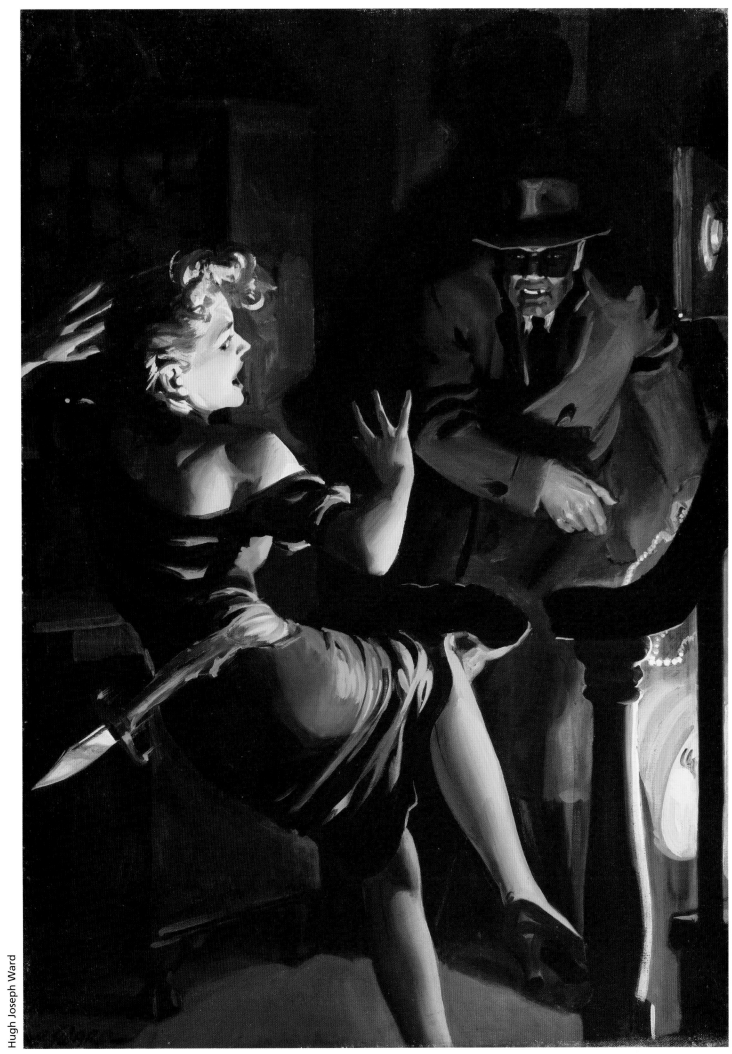

Hugh Joseph Ward

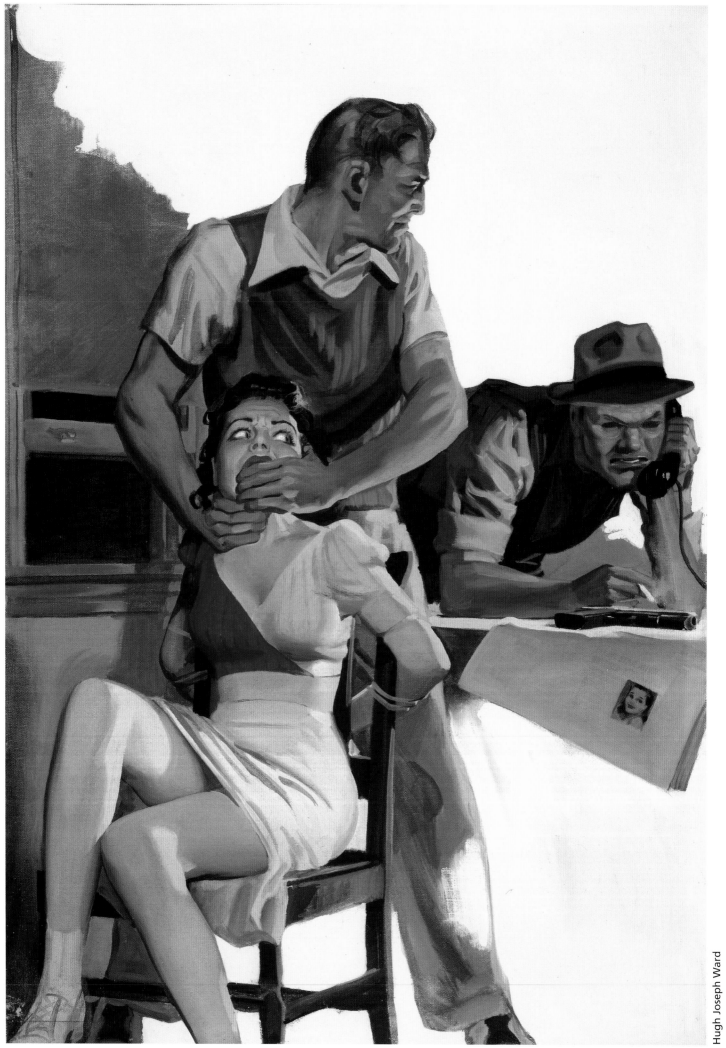

Hugh Joseph Ward

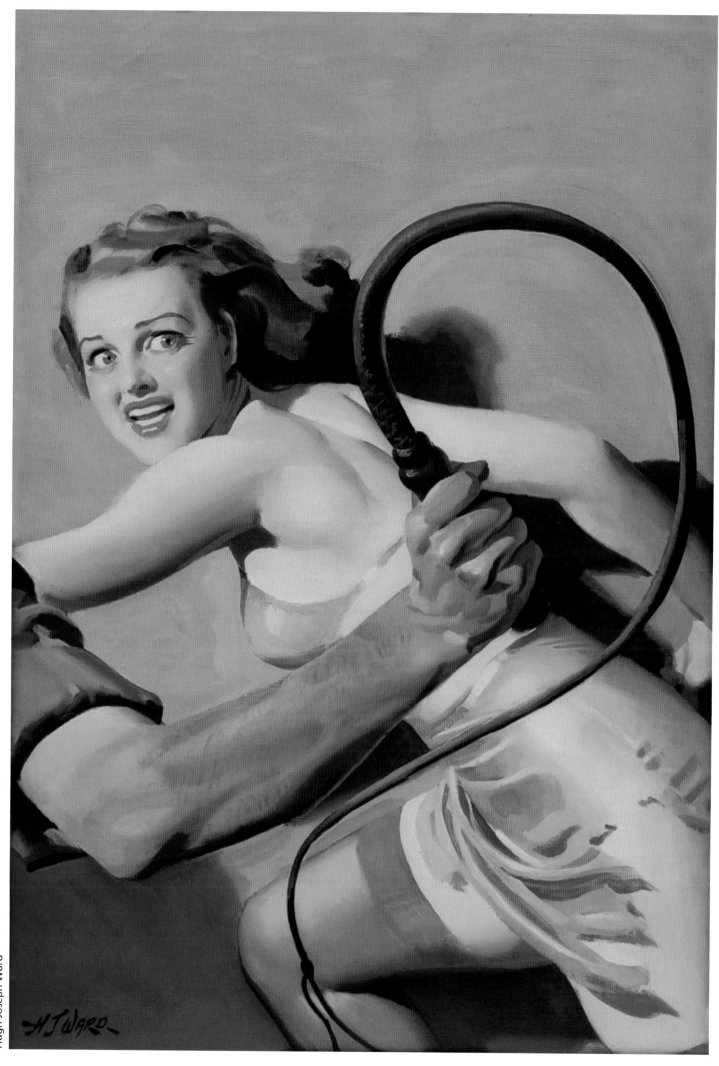

Hugh Joseph Ward

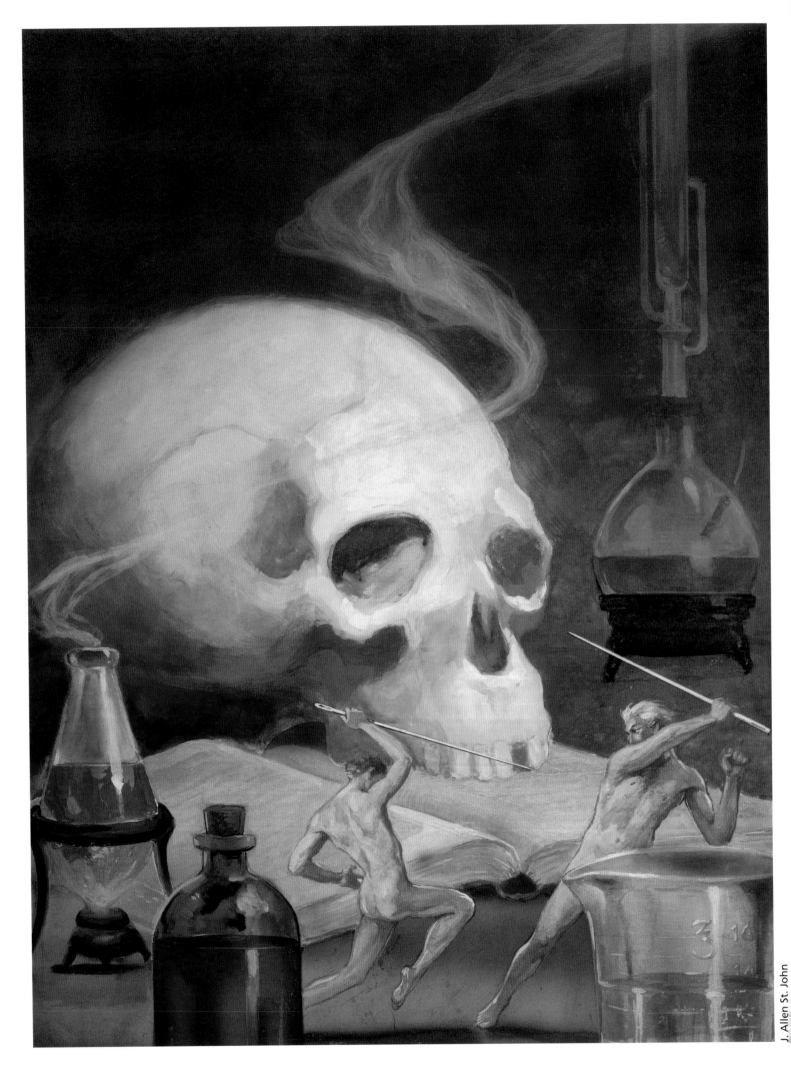

J. Allen St. John

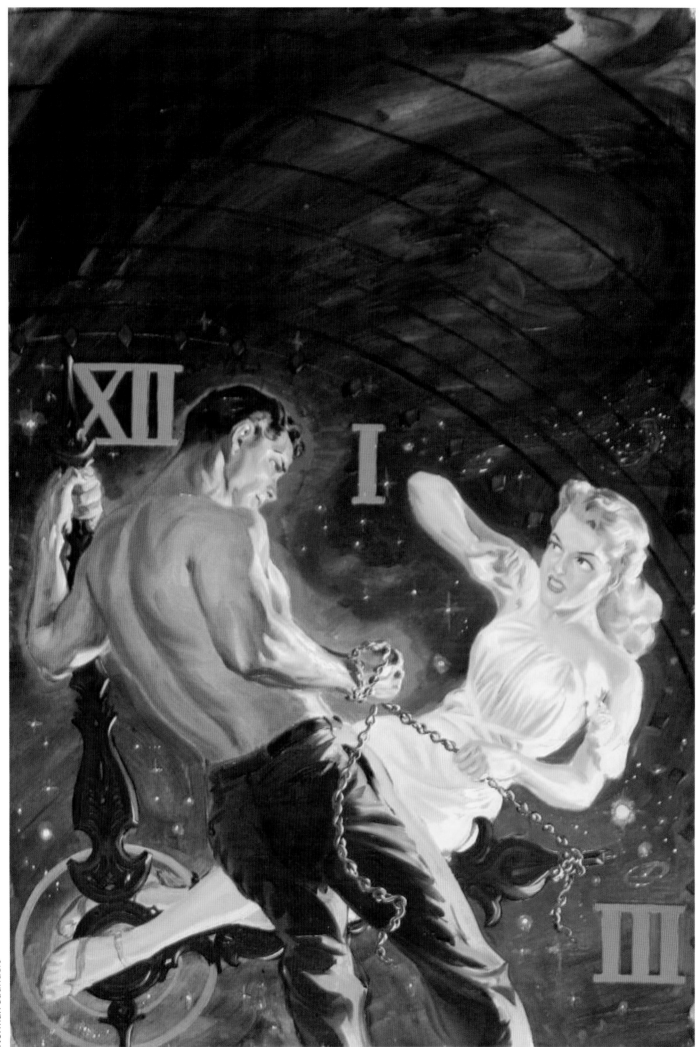

Norman Saunders

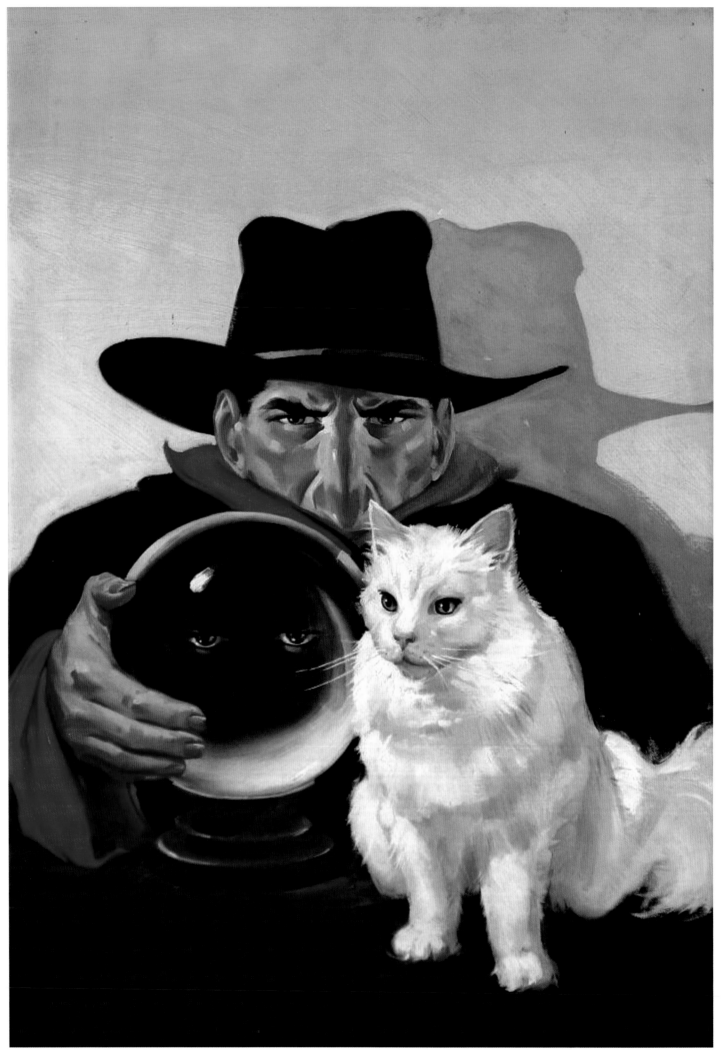

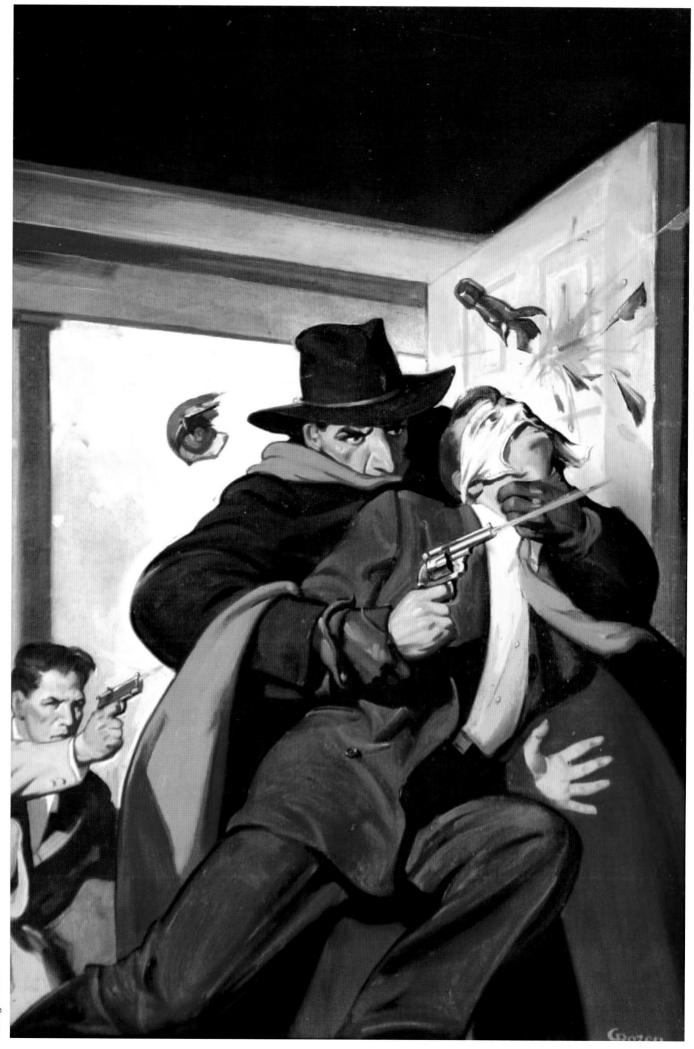

George Rozen

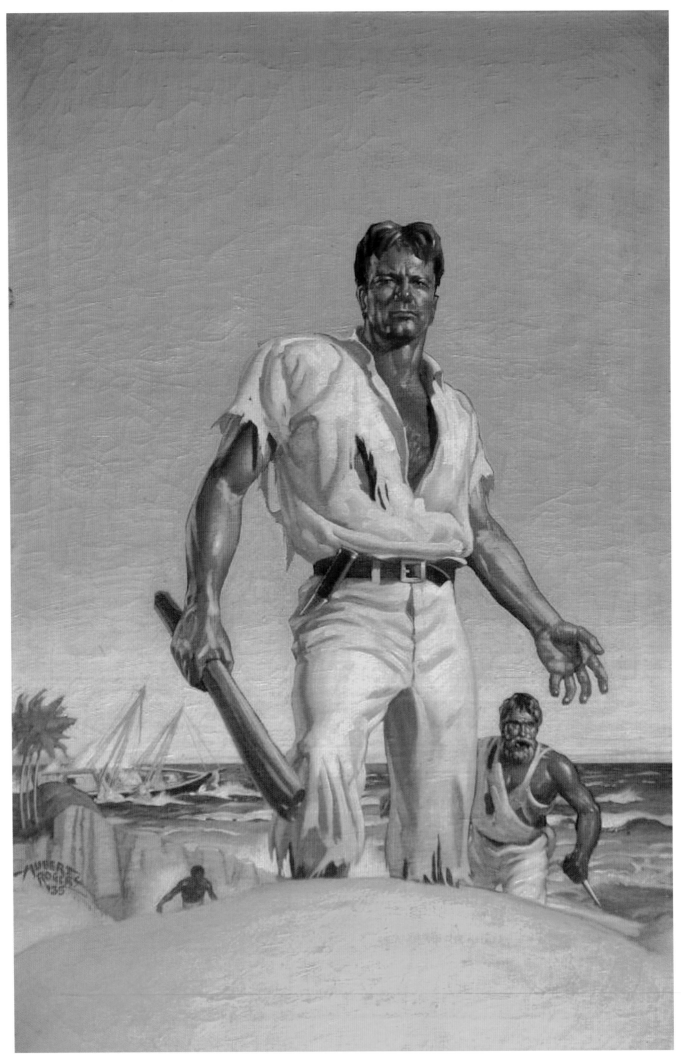

Savage Art

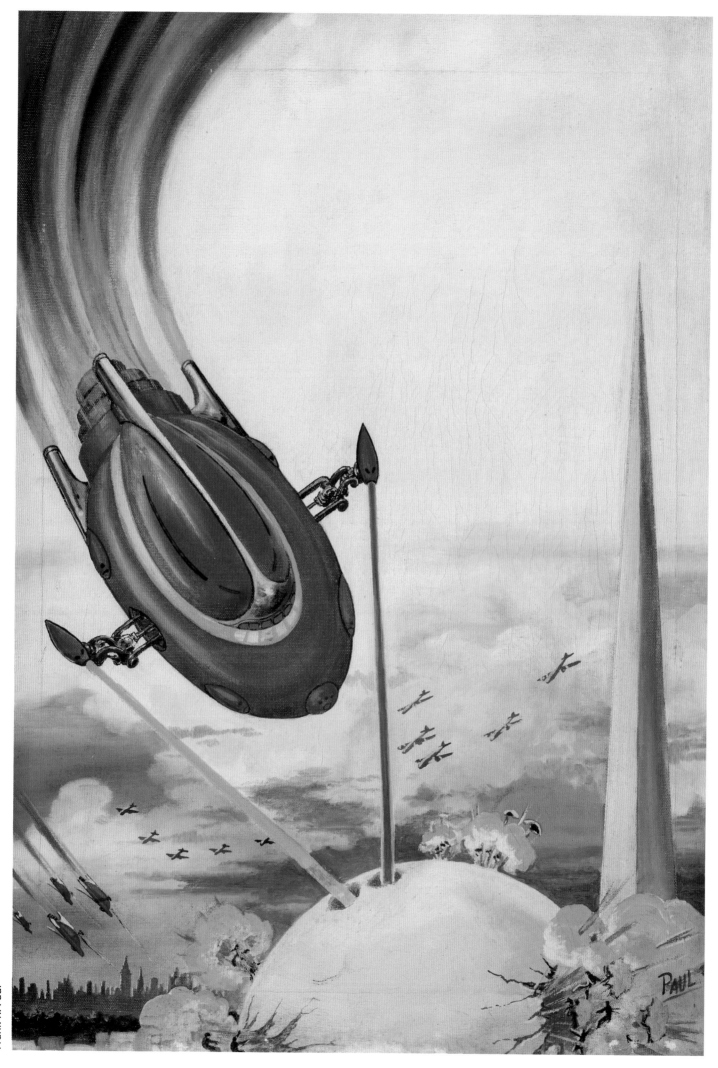

Frank R. Paul

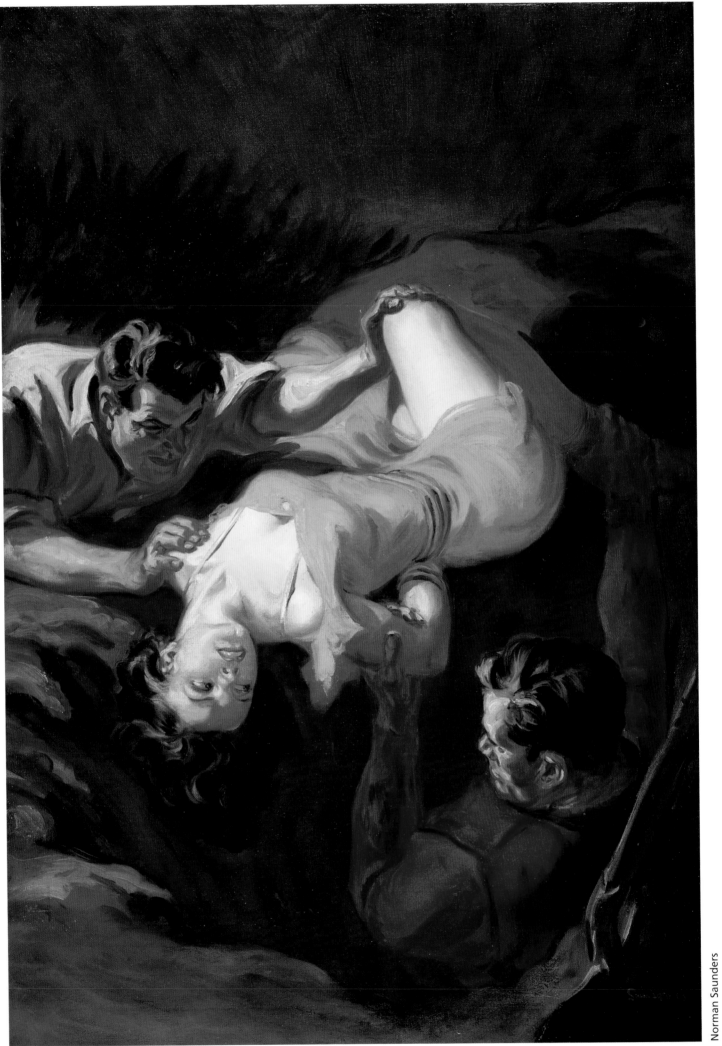

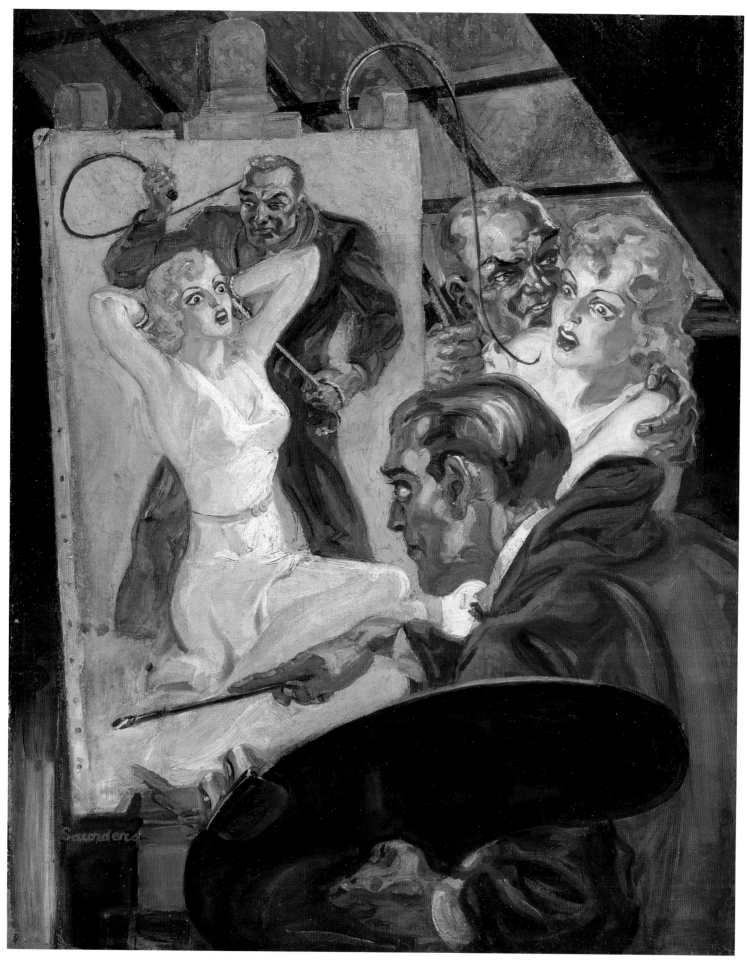

Norman Saunders

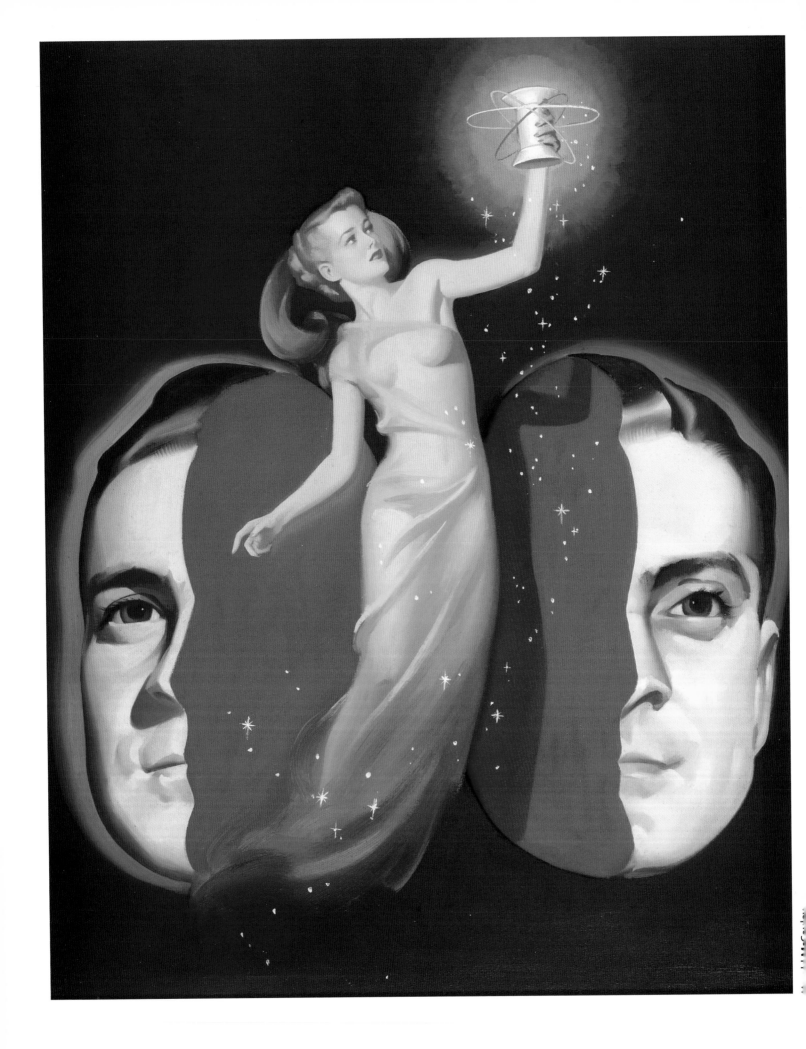

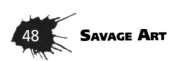

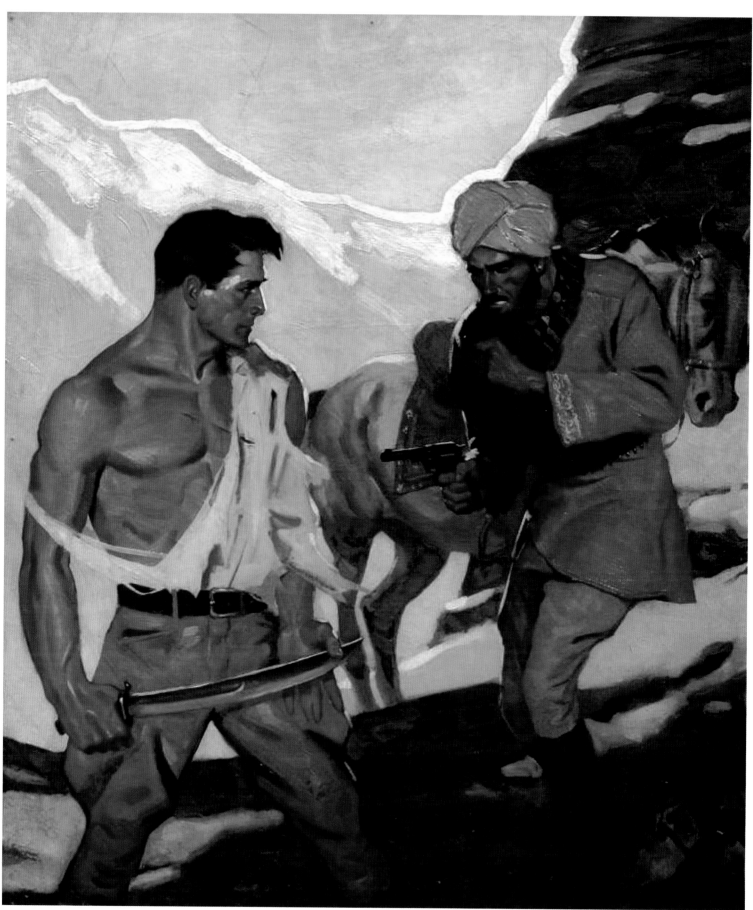

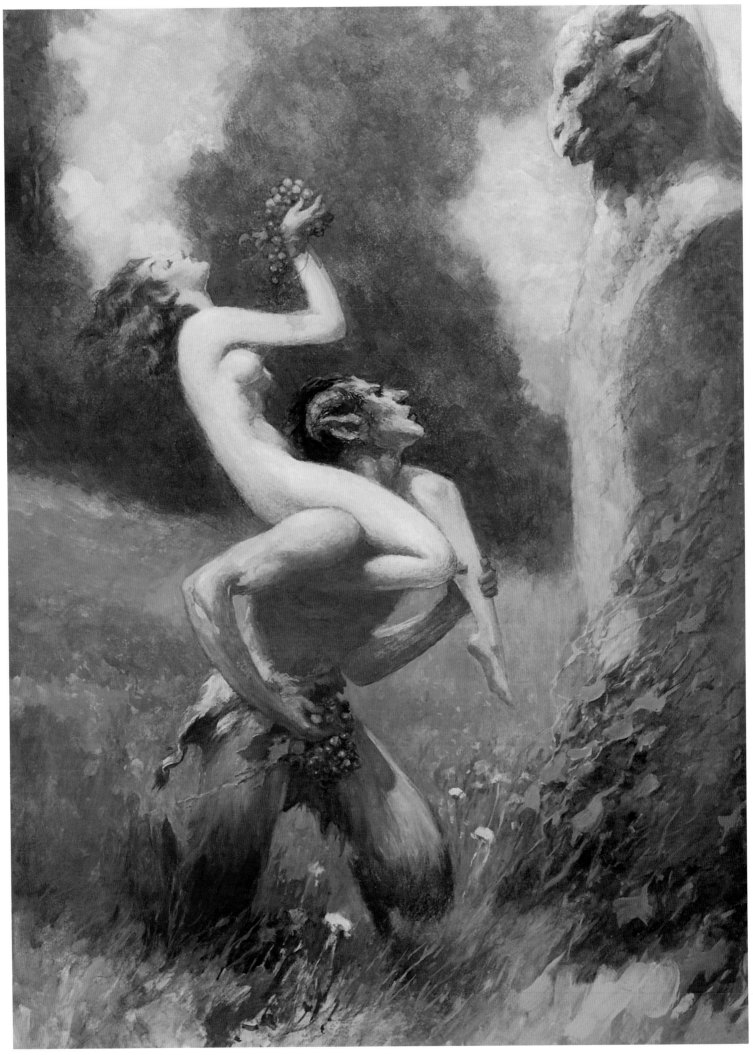

Frank R. Paul

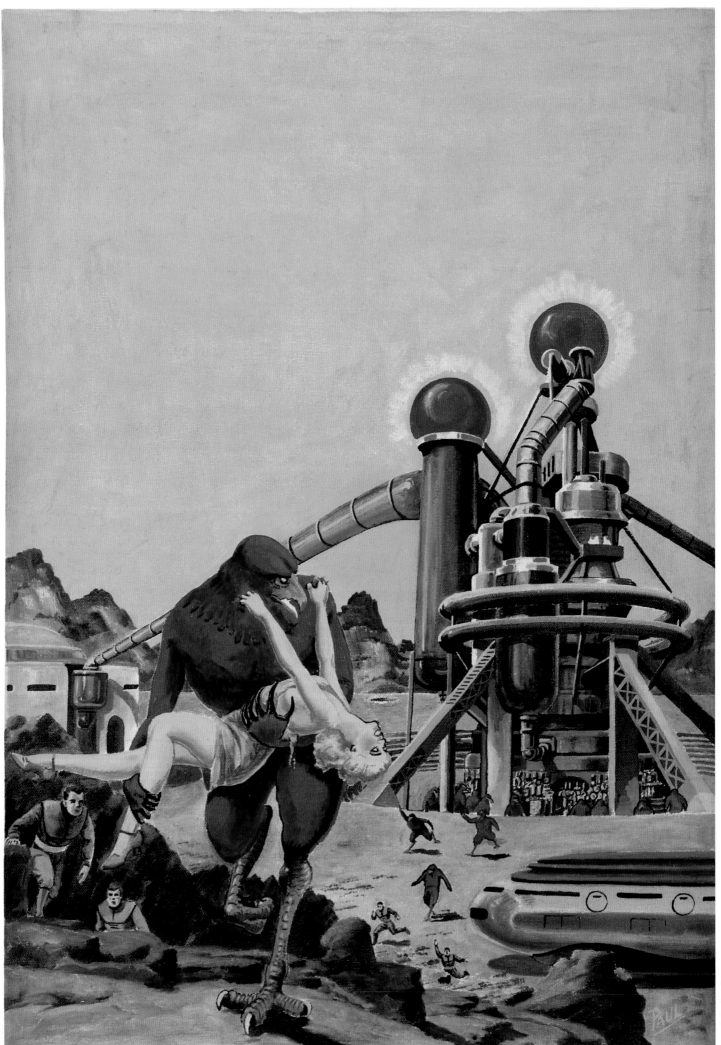

Frank R. Paul

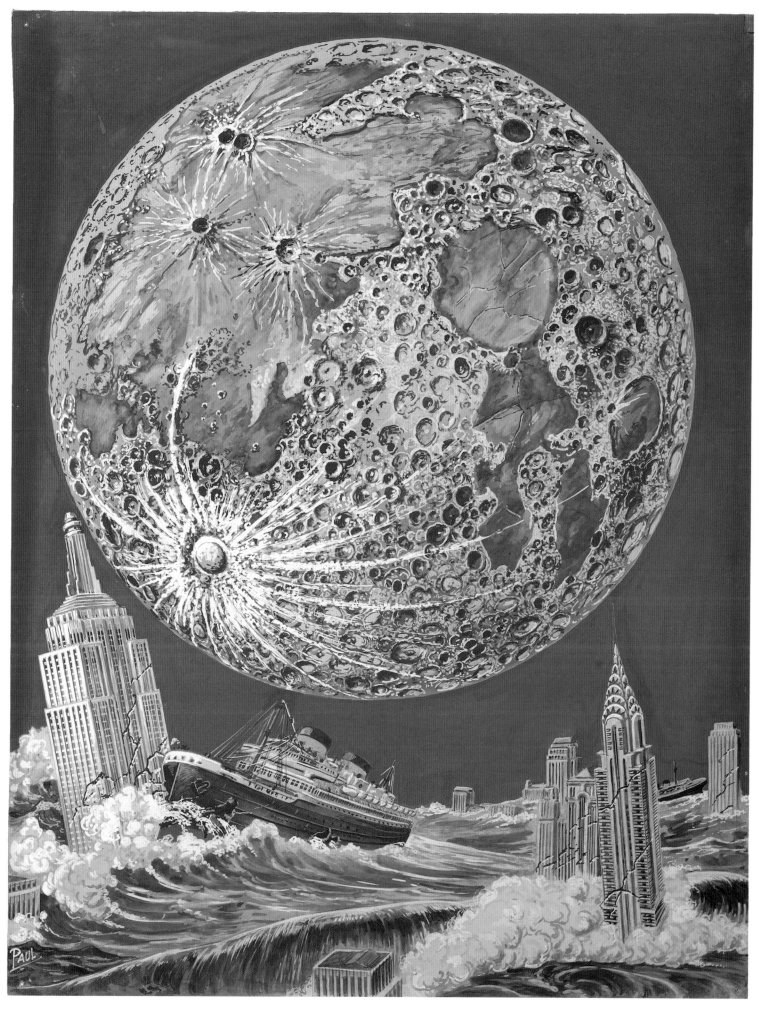

Frank R. Paul

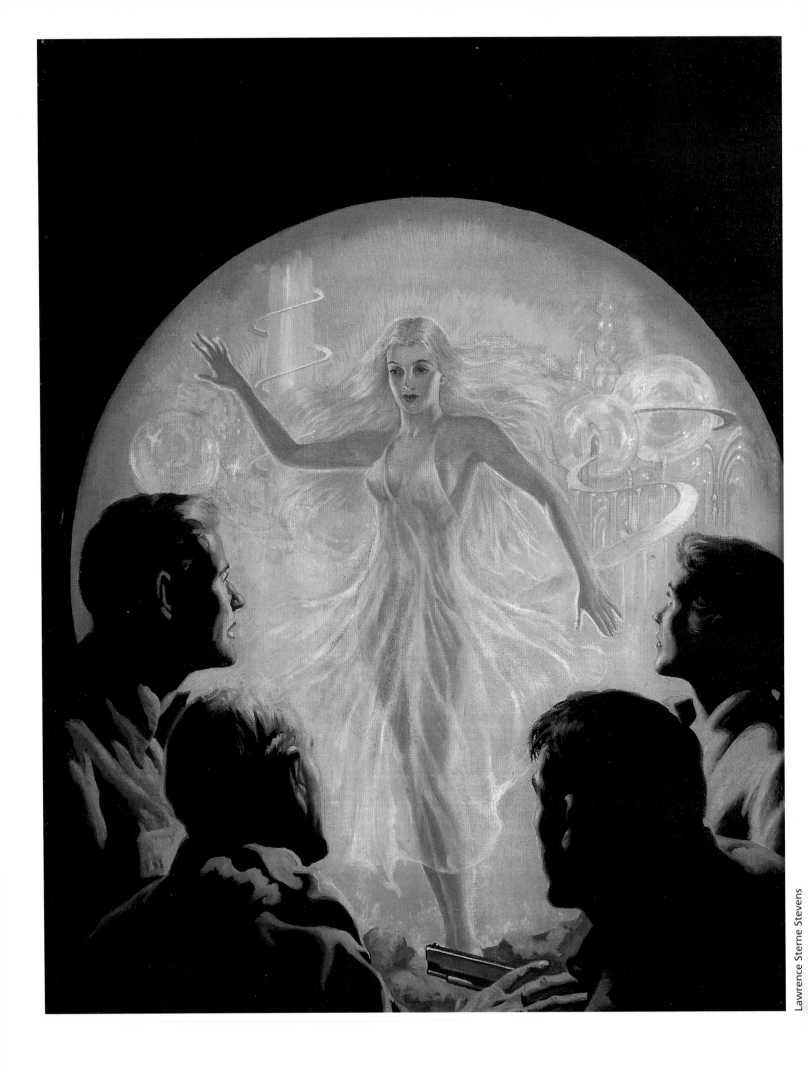

Lawrence Sterne Stevens

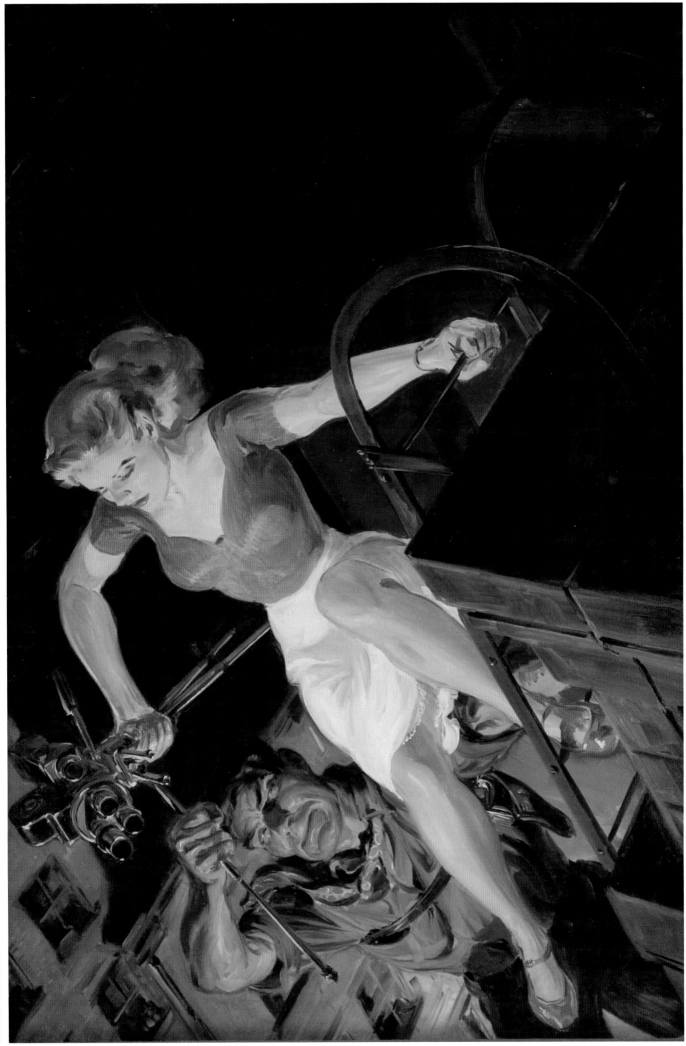

Norman Saunders

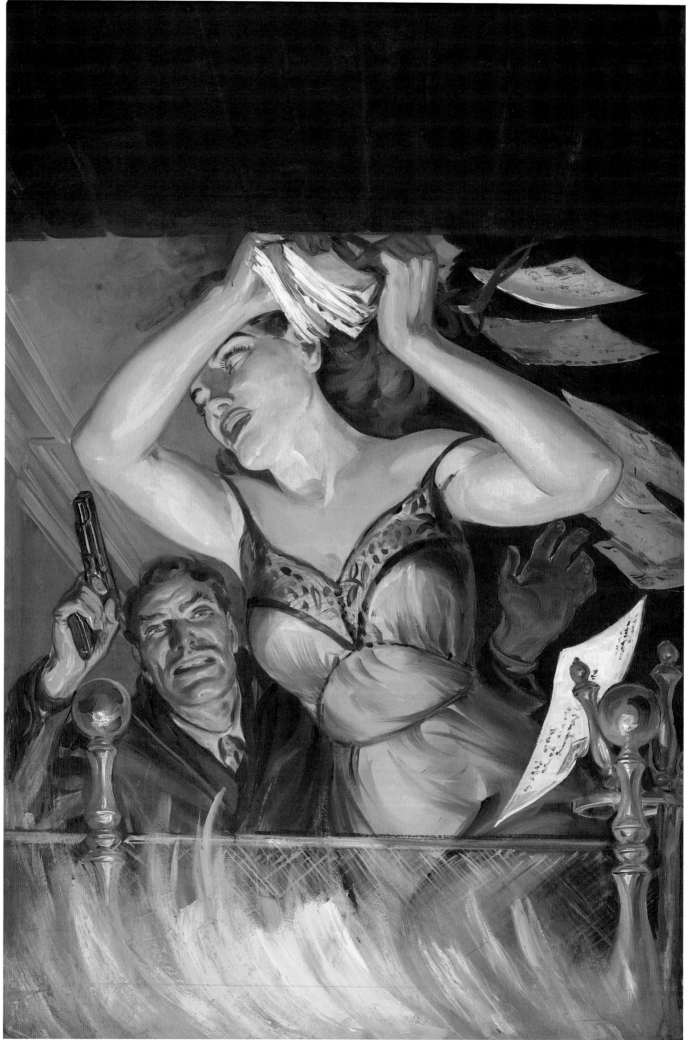

Norman Saunders

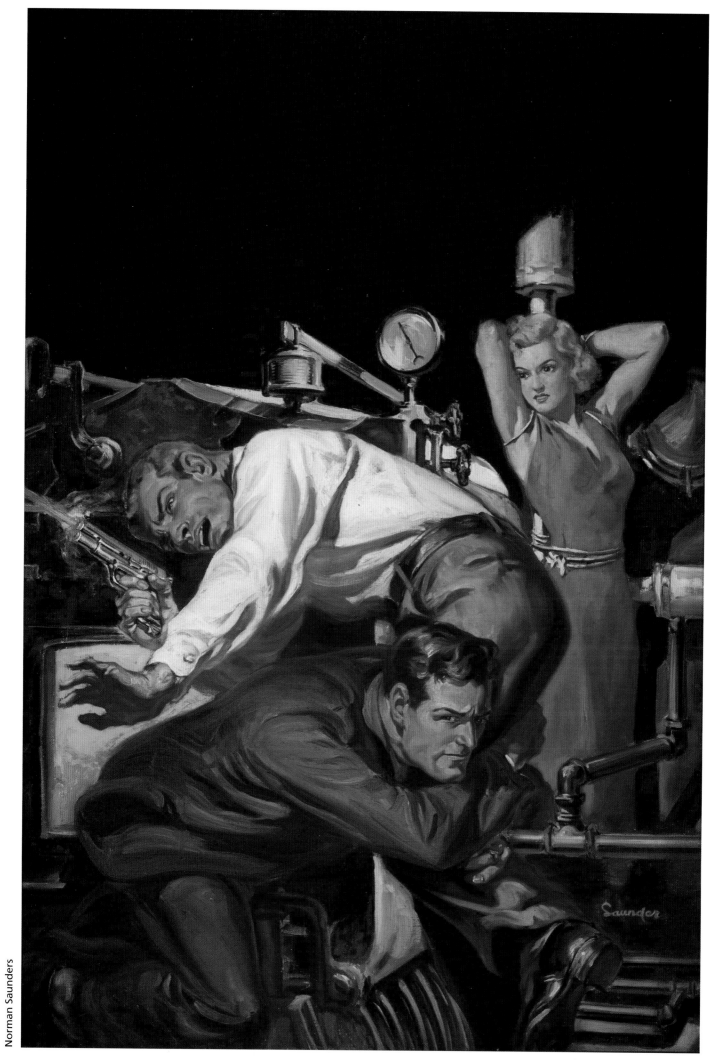

Norman Saunders

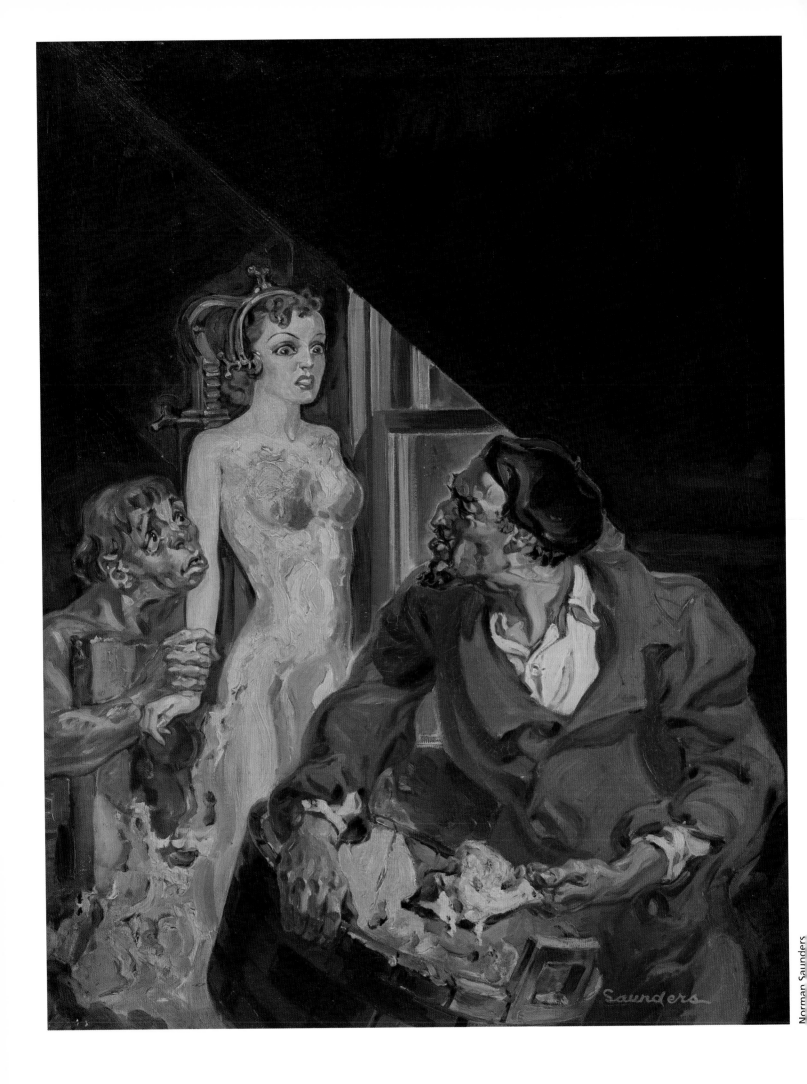

Norman Saunders

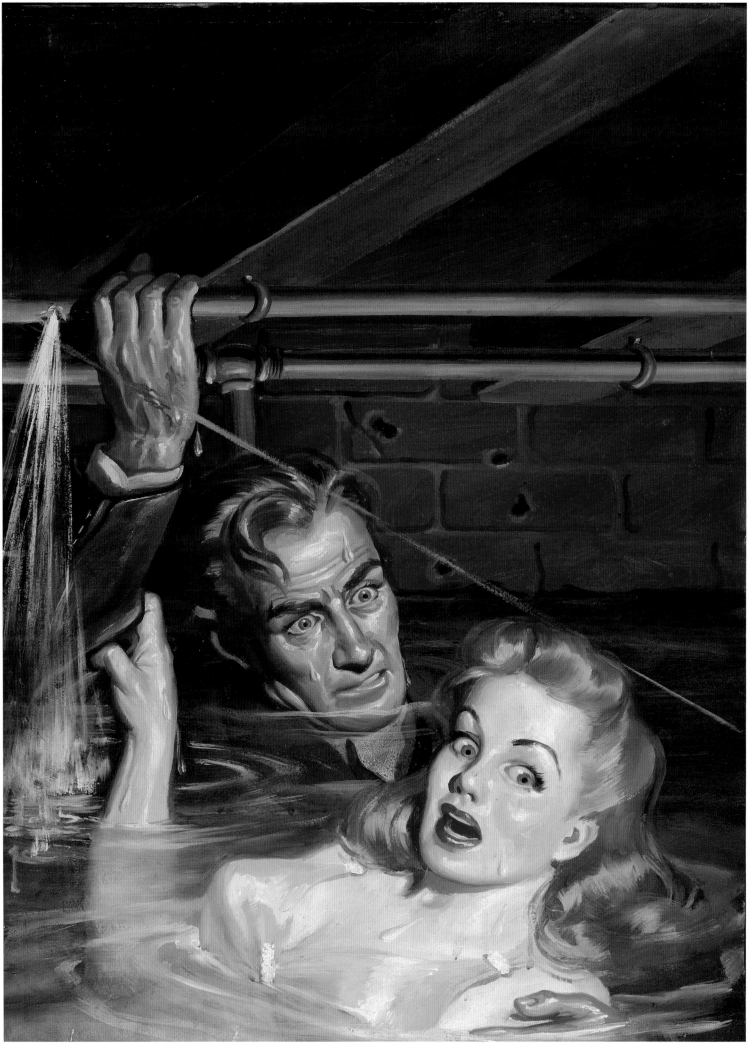

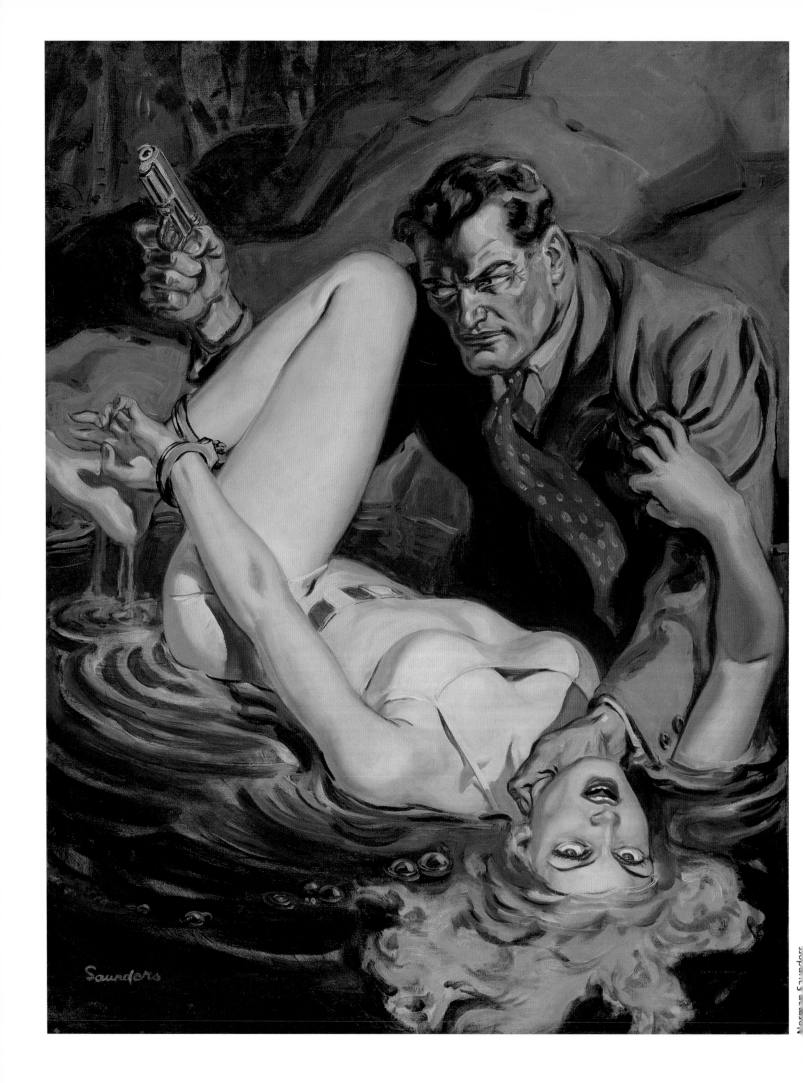

Savage Art

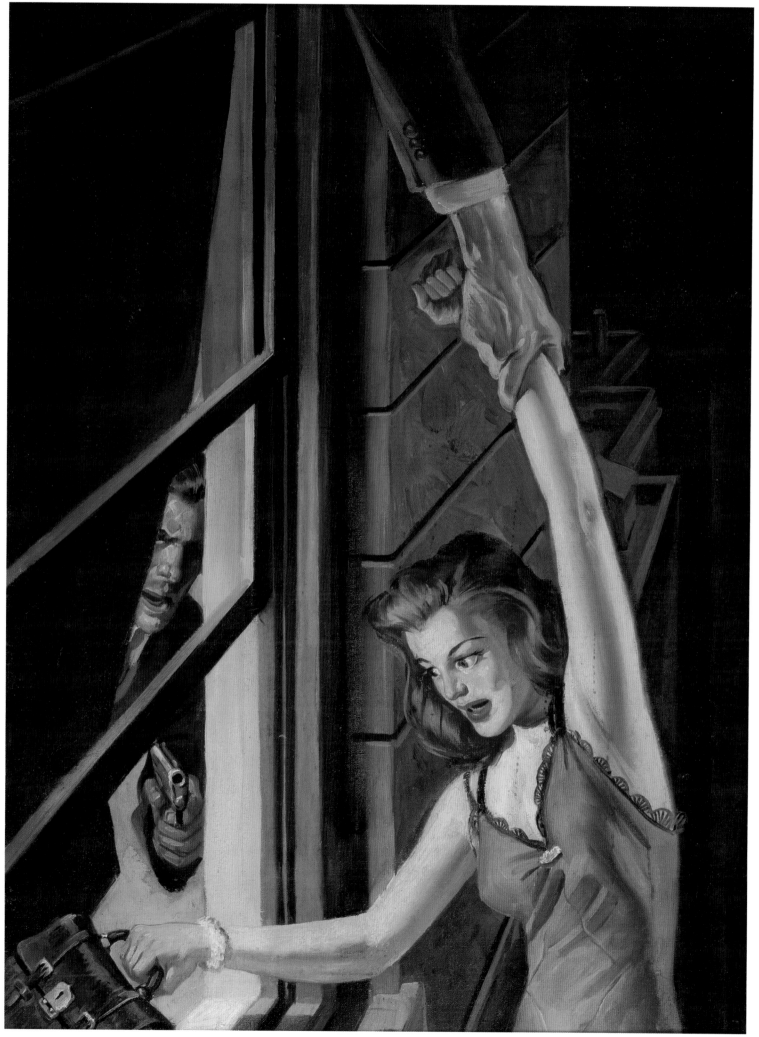

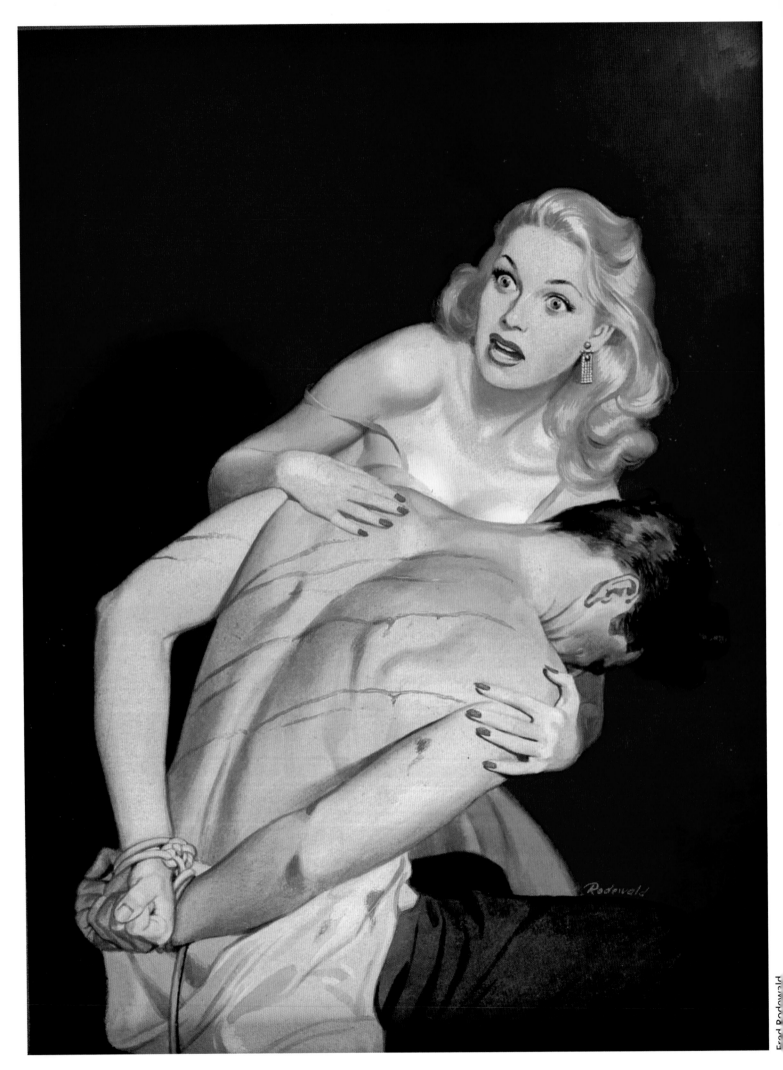

SAVAGE ART

Fred Rodewald

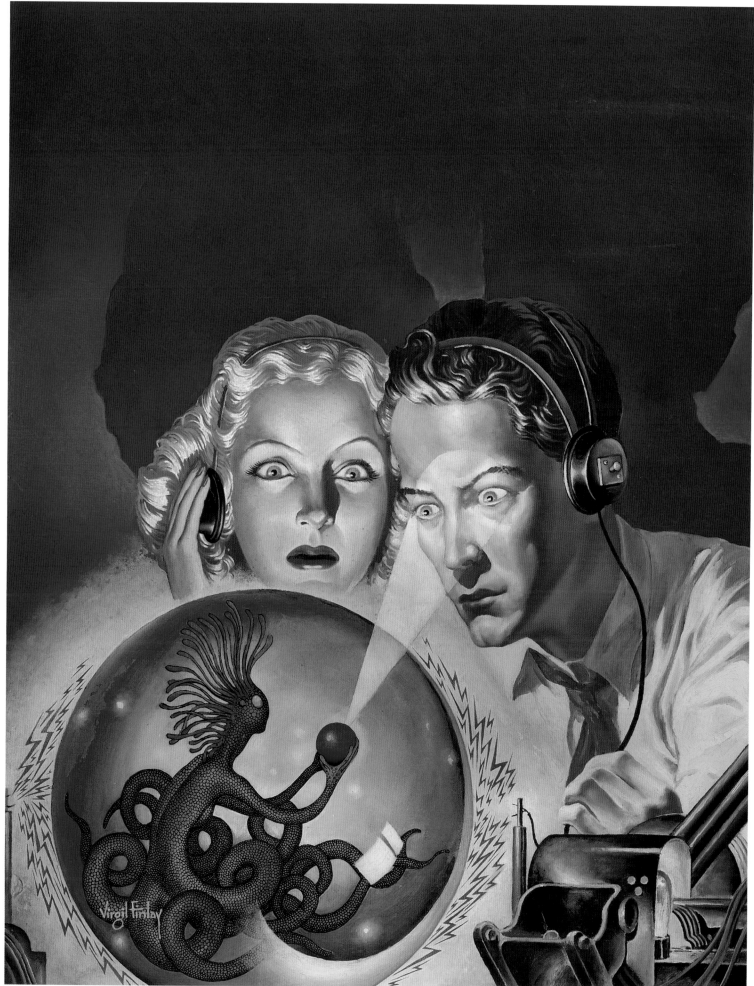

Virgil Finlay

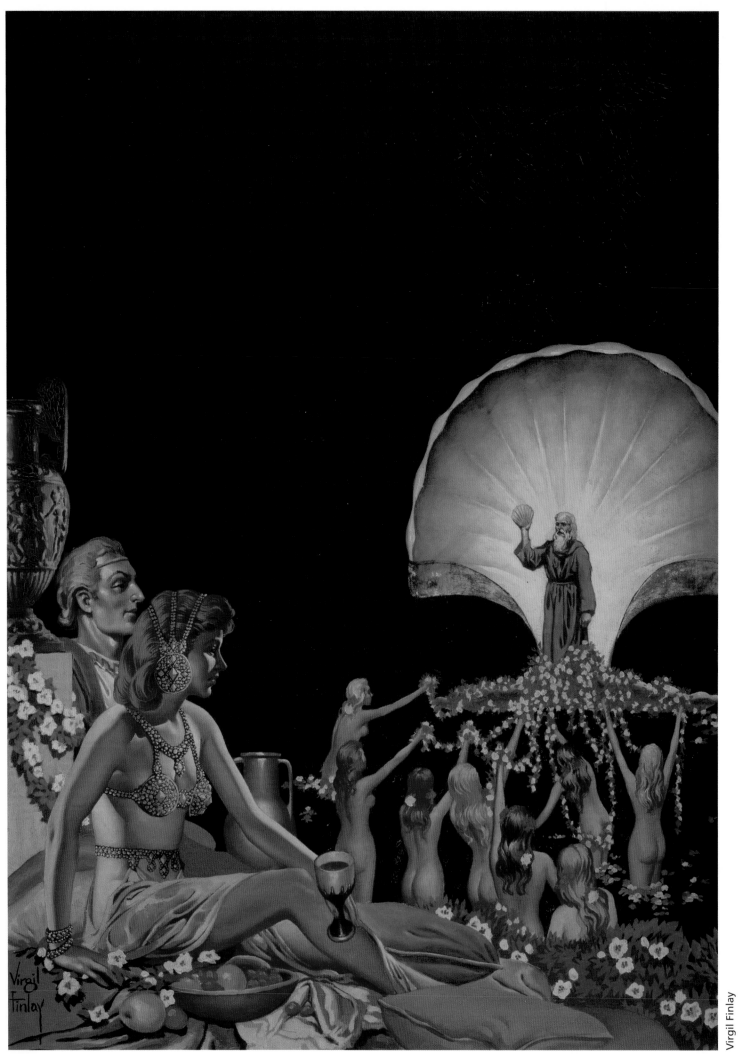

Virgil Finlay

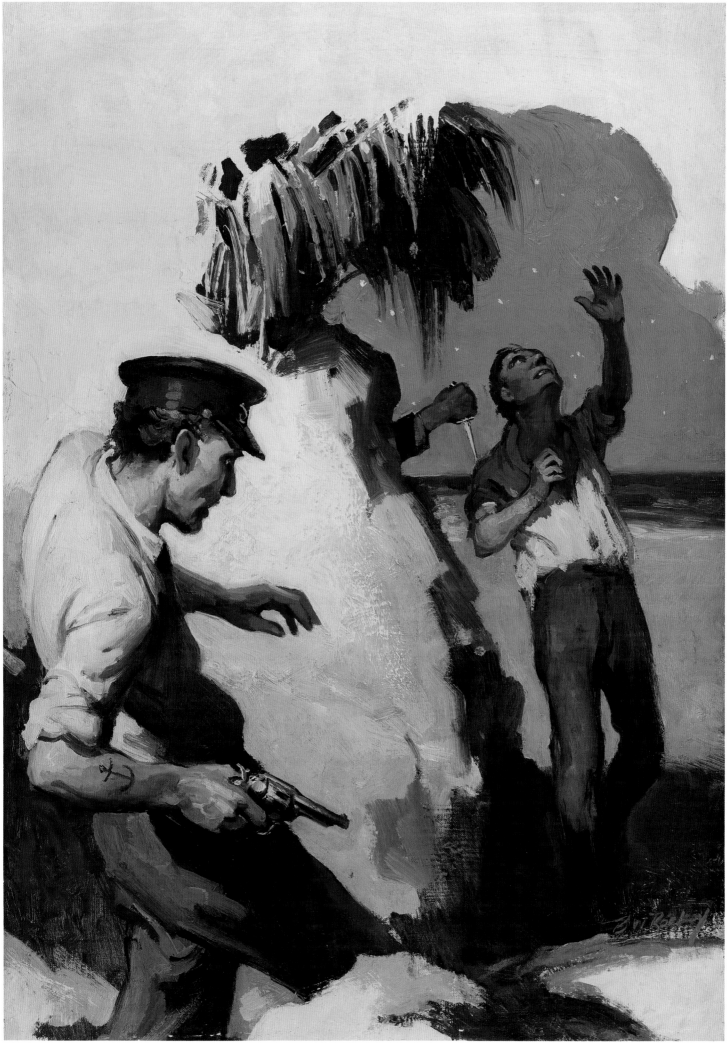

B.W. Rockey

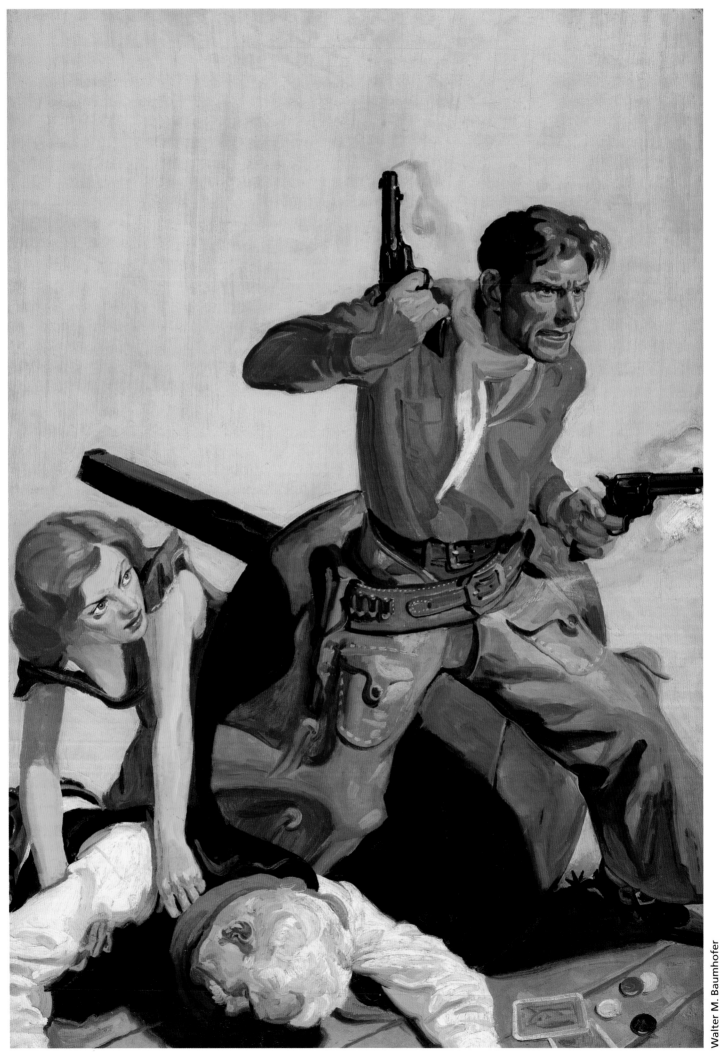

 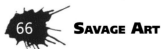

Walter M. Baumhofer

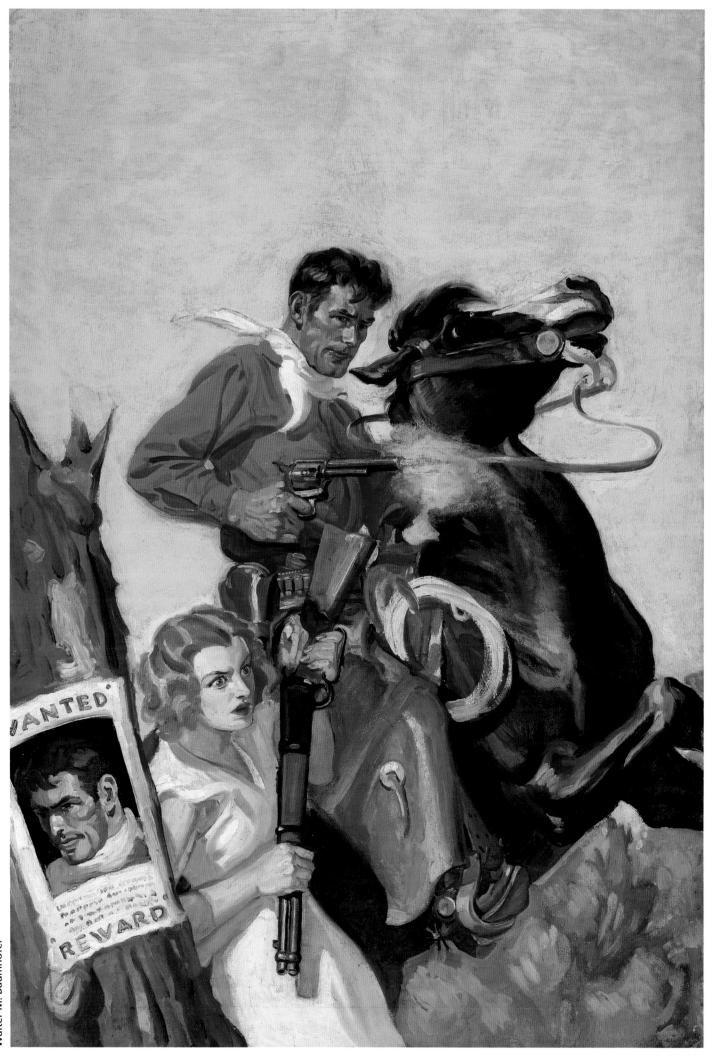

Walter M. Baumhofer

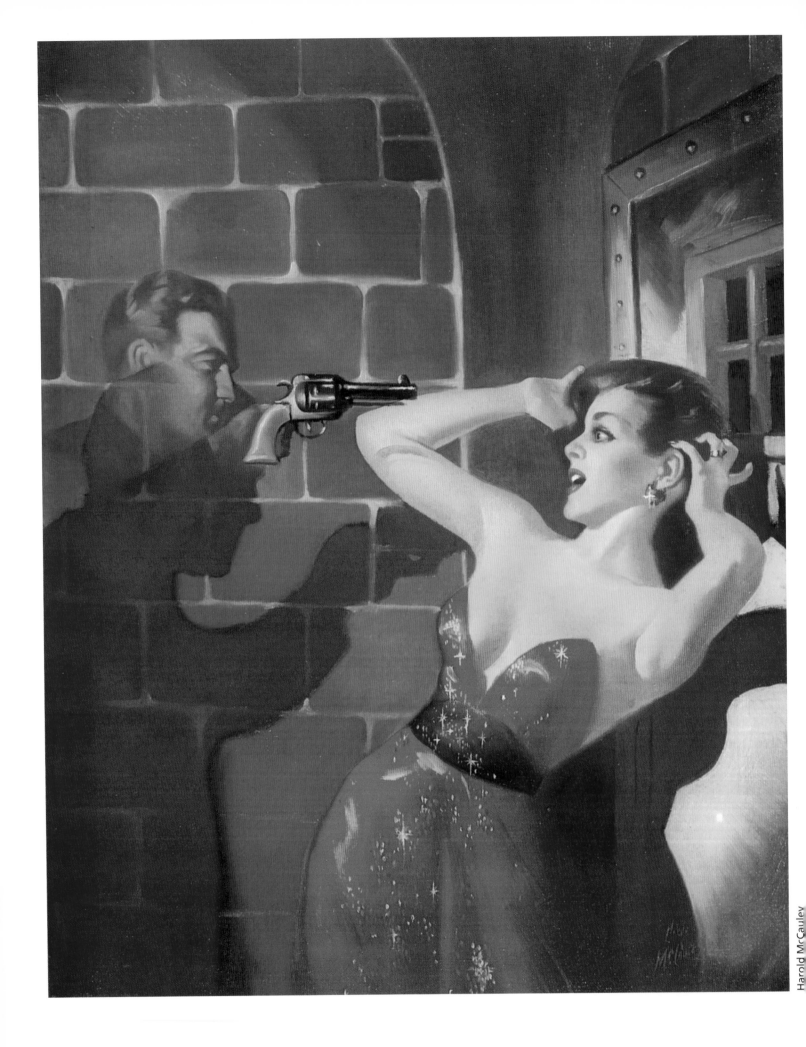

Harold McCauley

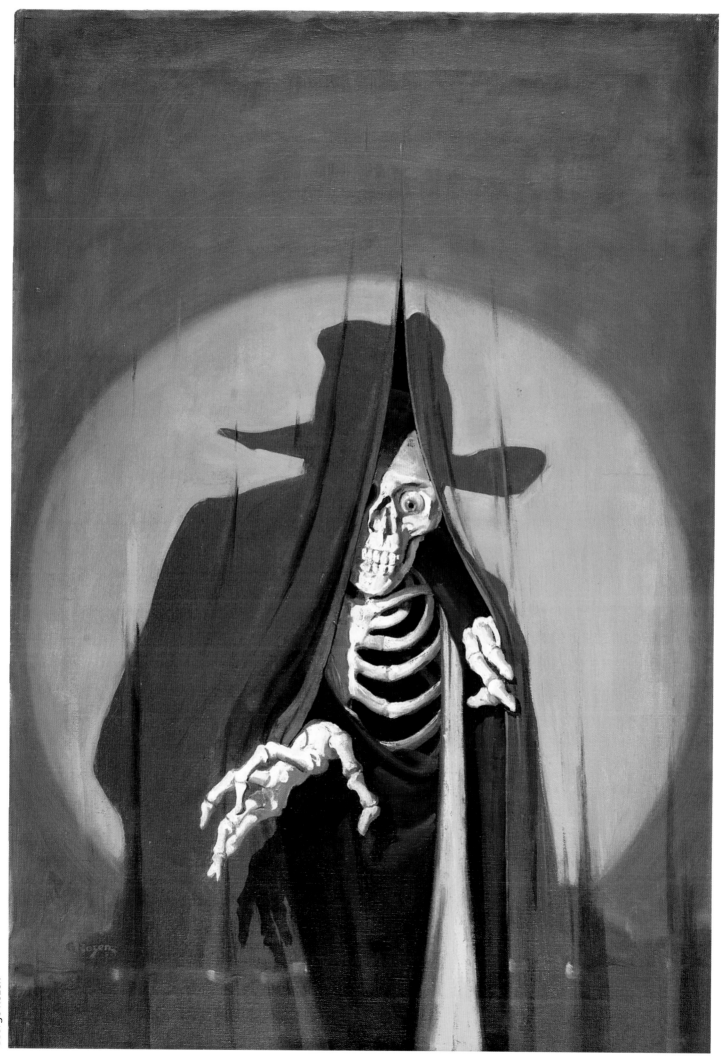

George Rozen

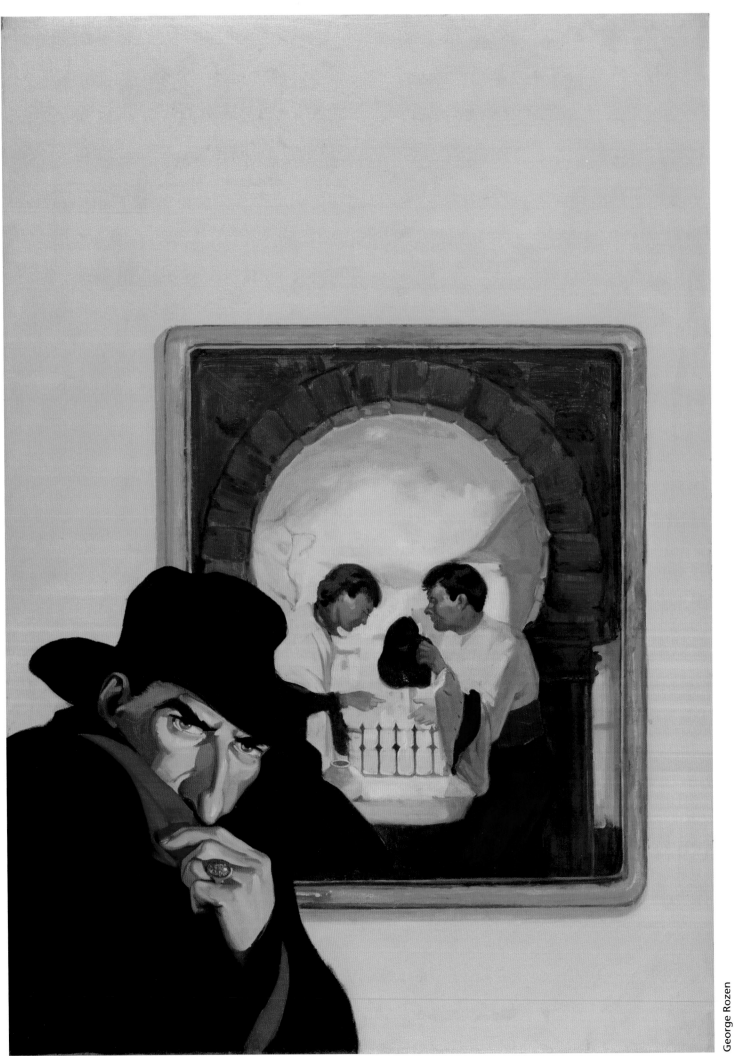

George Rozen

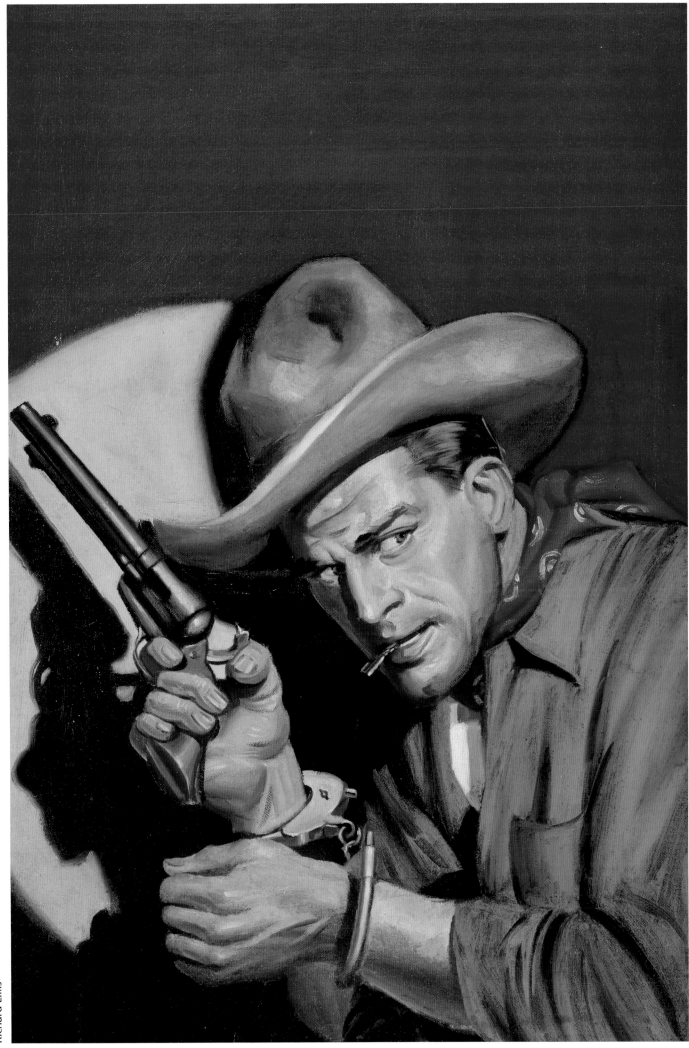

Richard Lillis

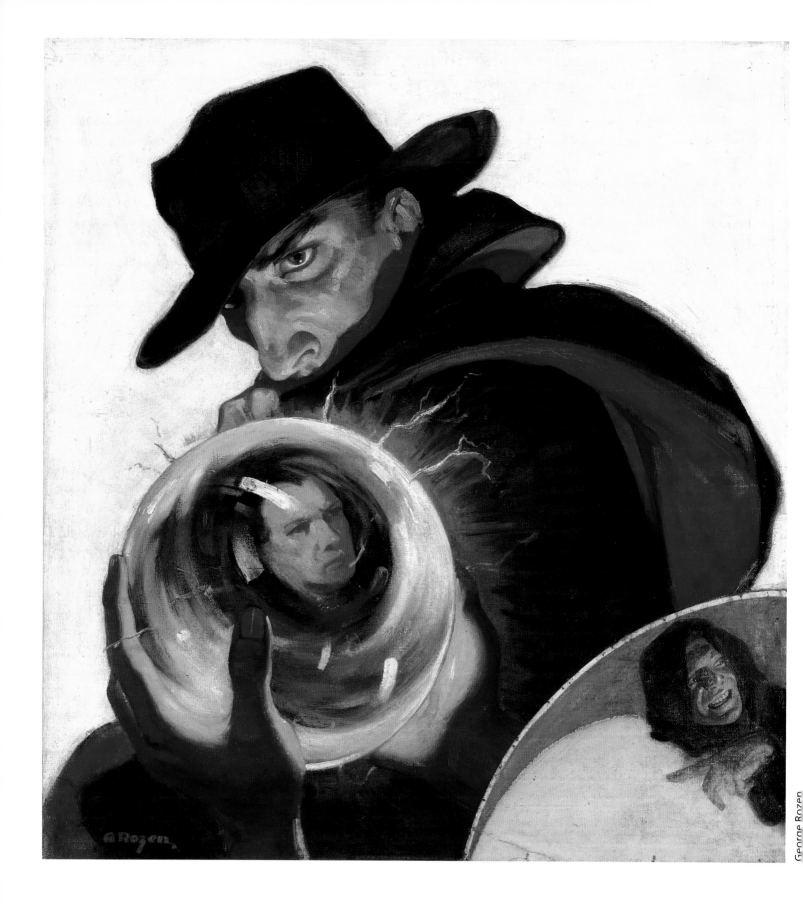

George Rozen

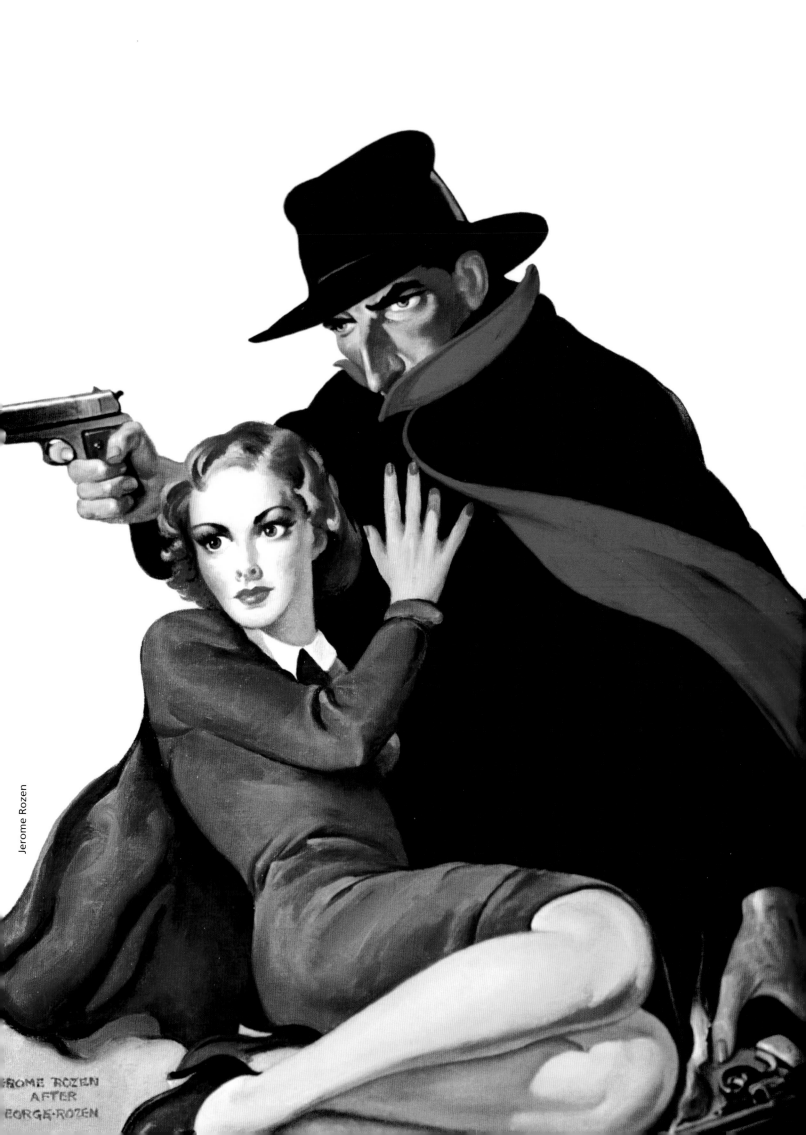

Jerome Rozen

JEROME ROZEN
AFTER
GEORGE ROZEN

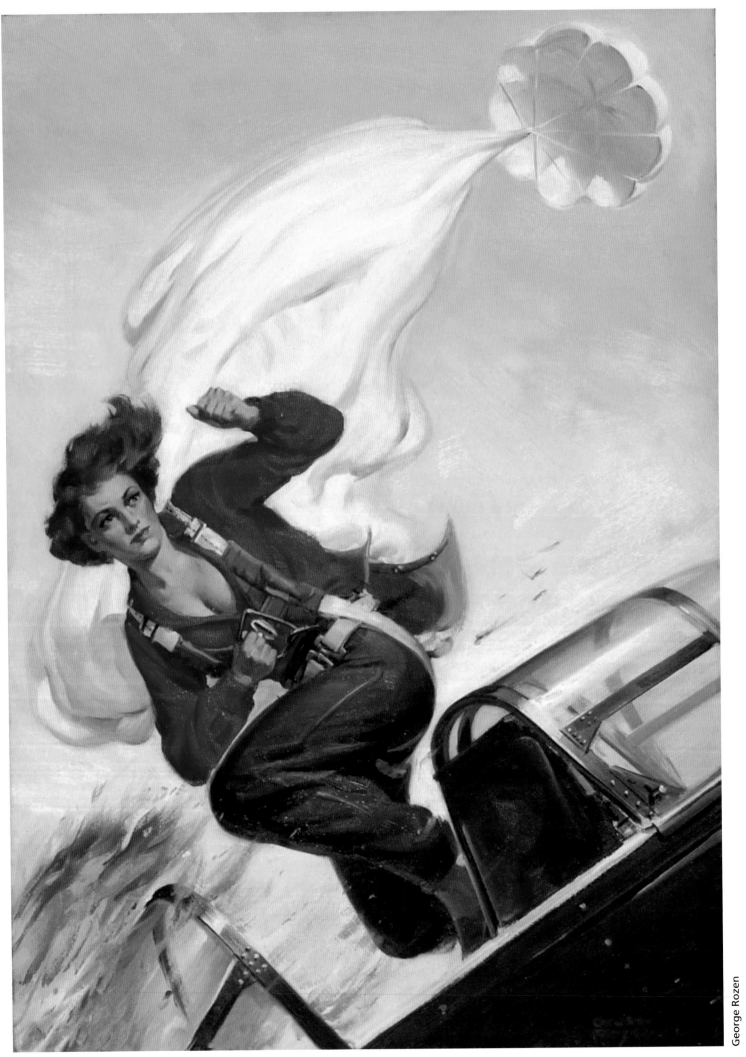

George Rozen

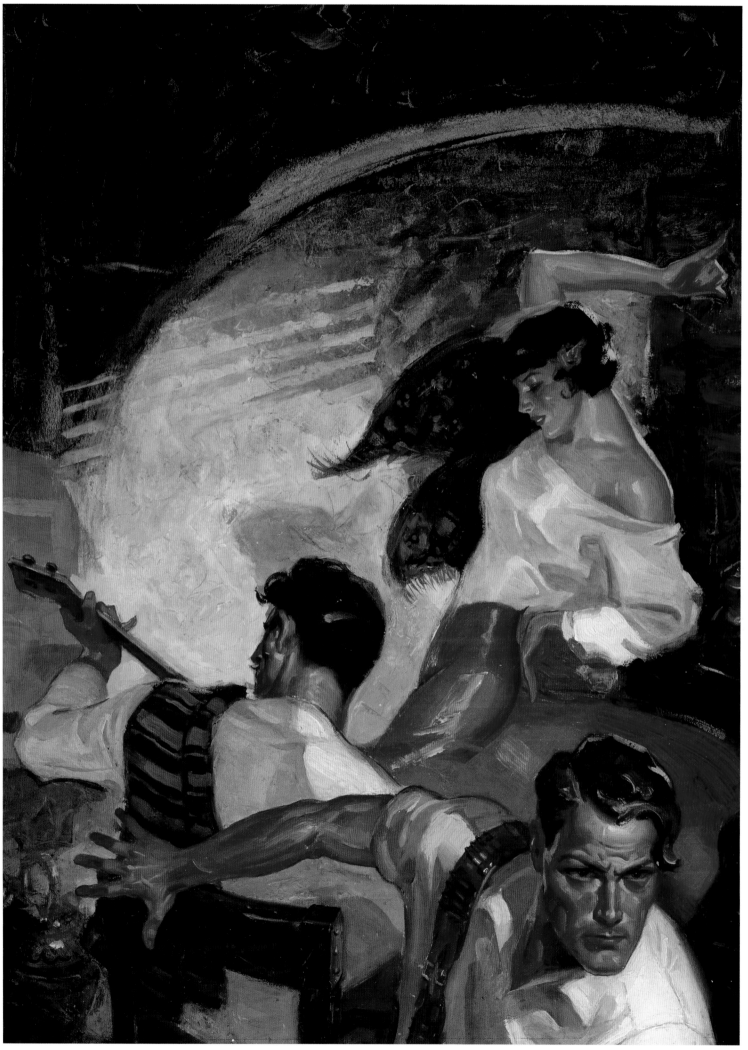

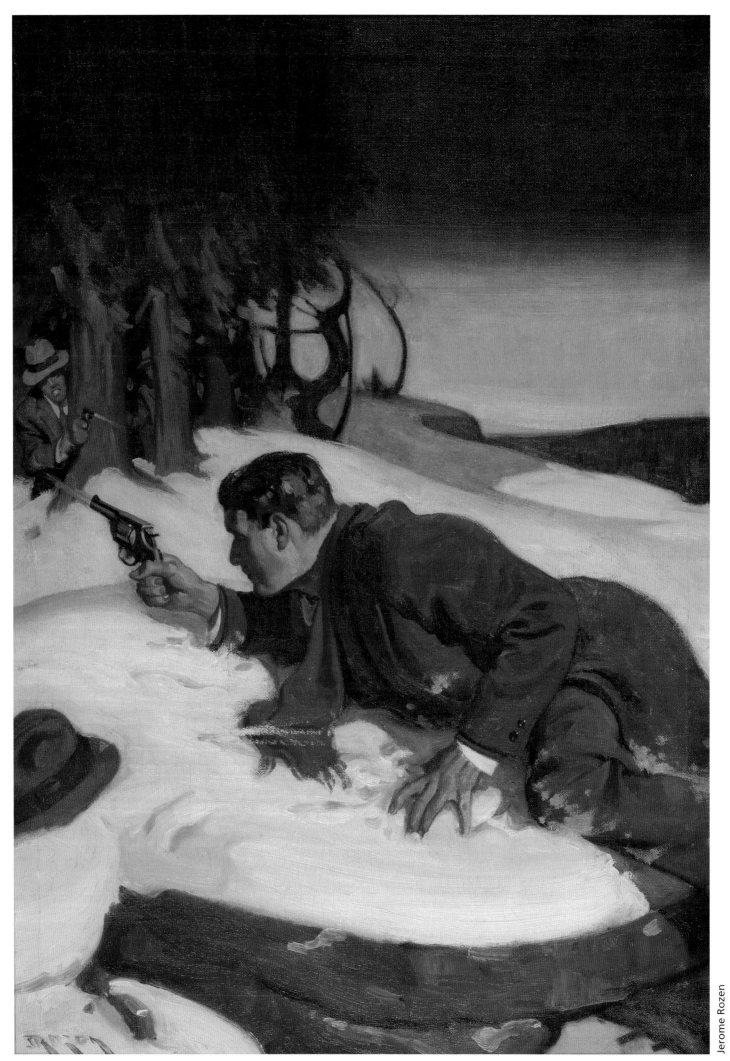

SAVAGE ART

Jerome Rozen

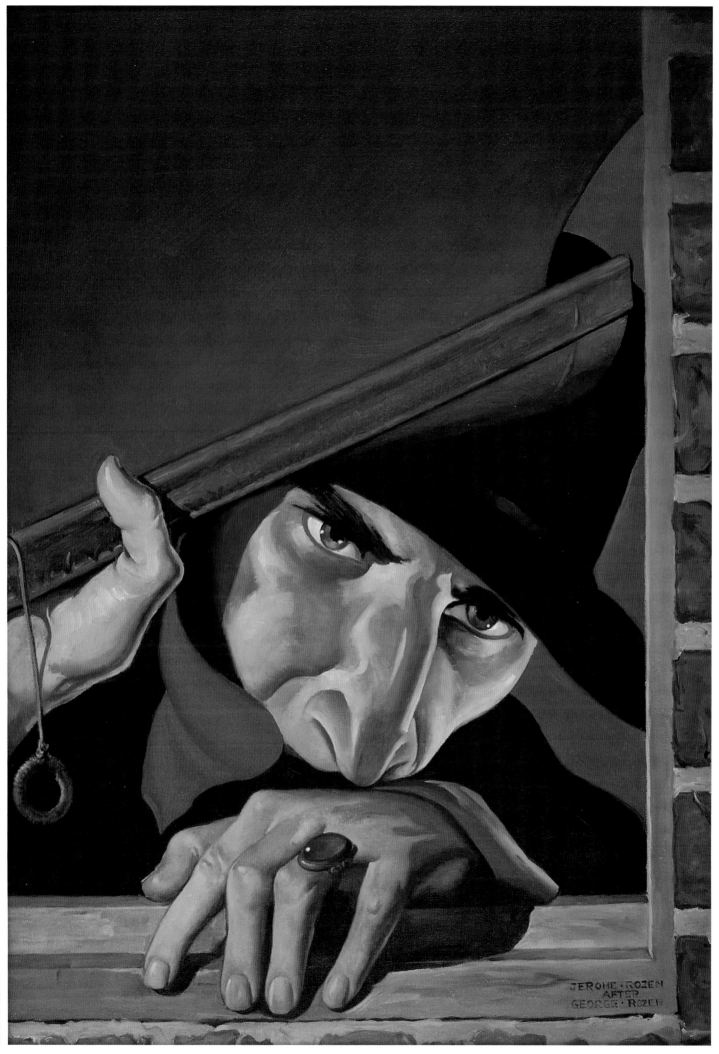

Jerome Rozen

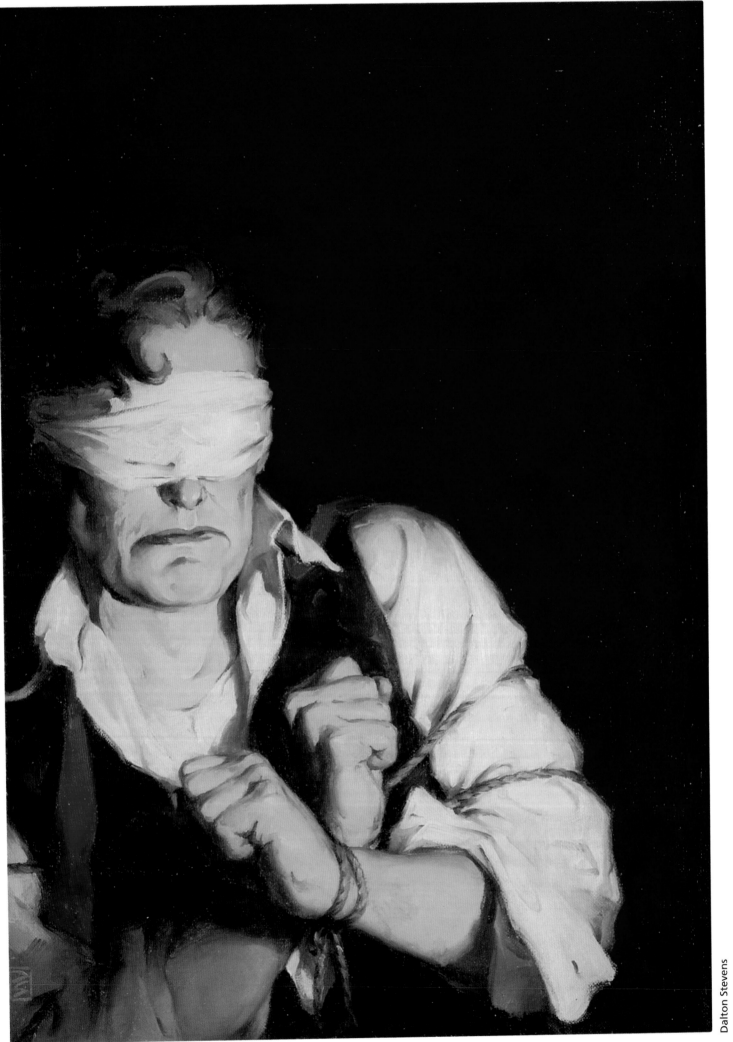

SAVAGE ART

Delos Palmer

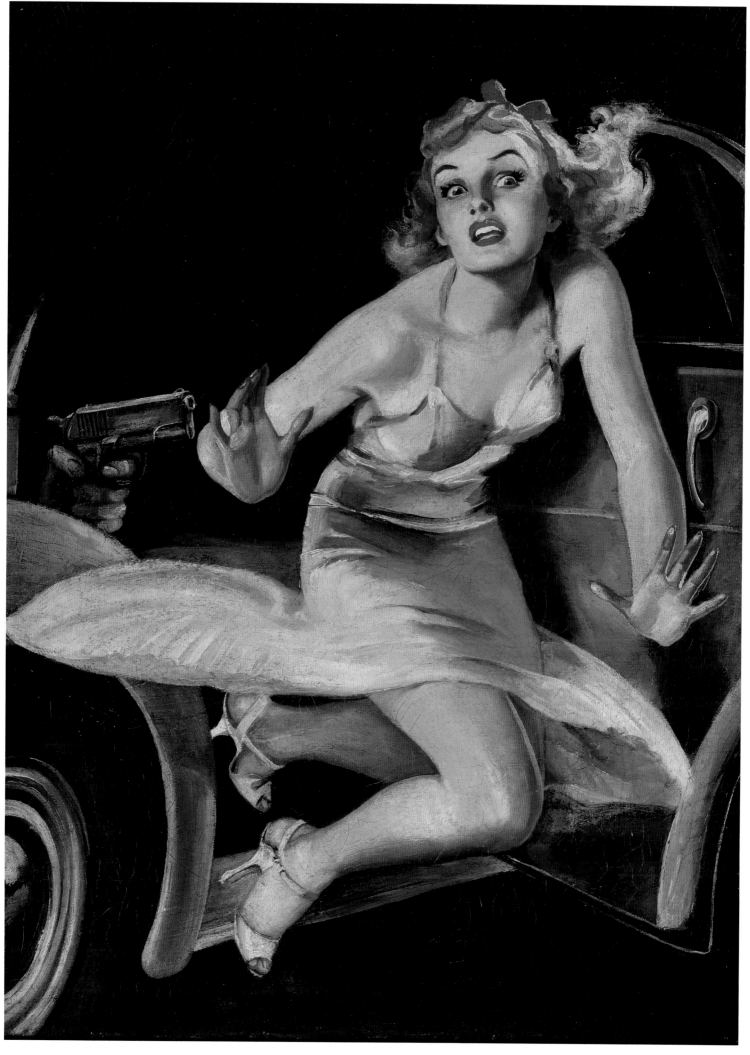

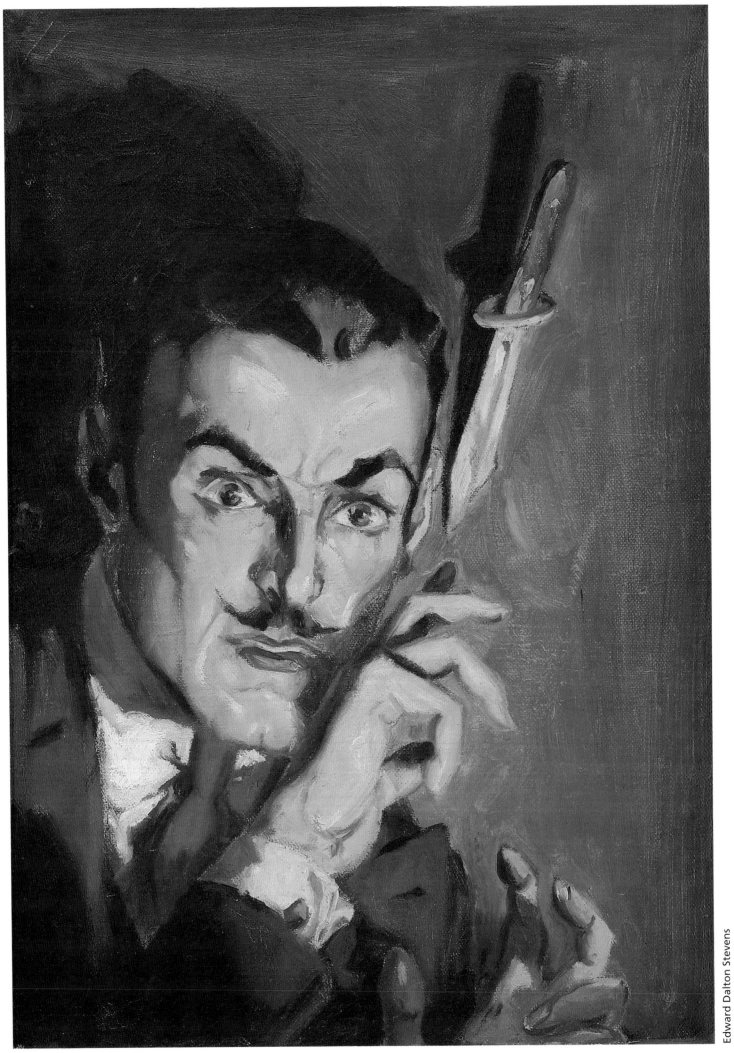

Edward Dalton Stevens

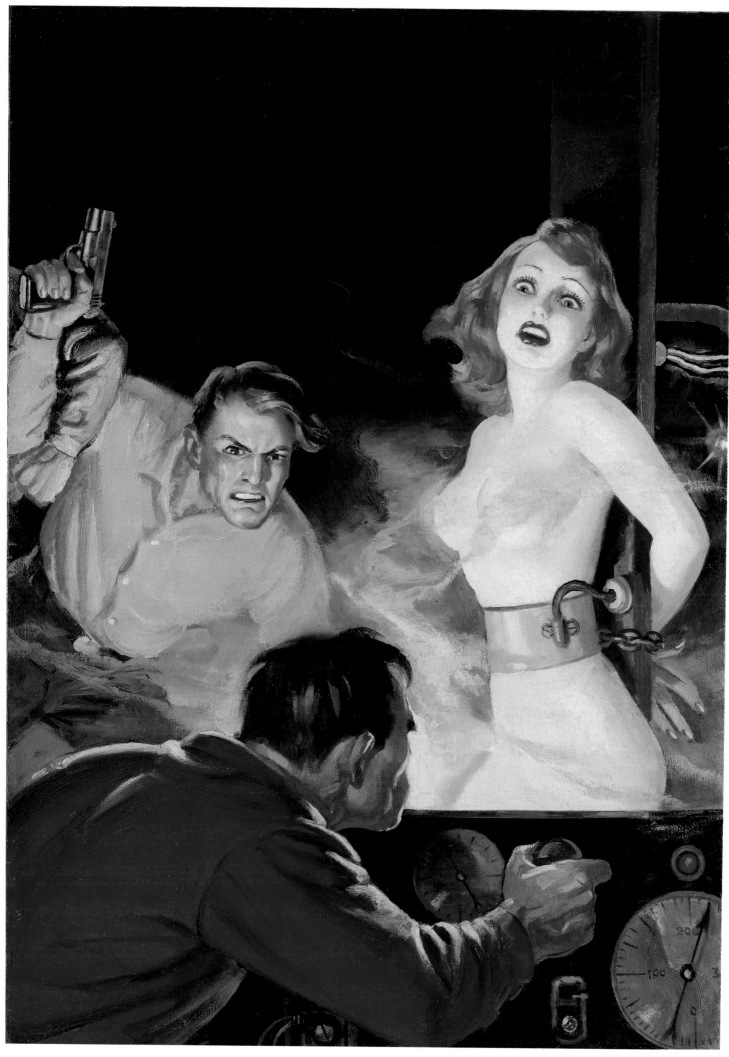

William F. Soare

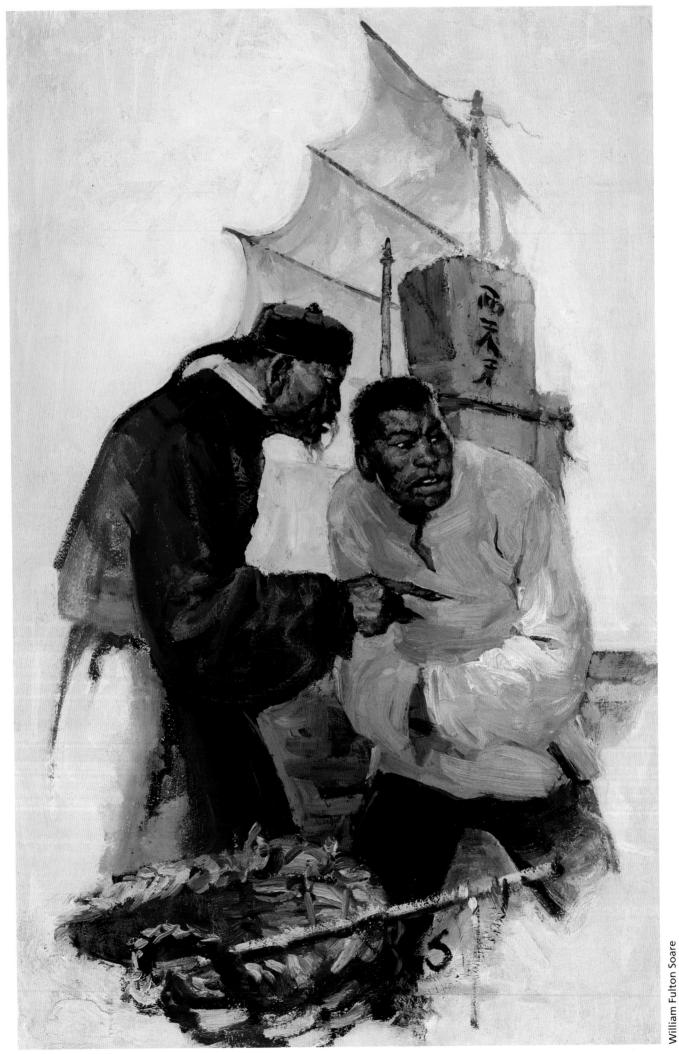

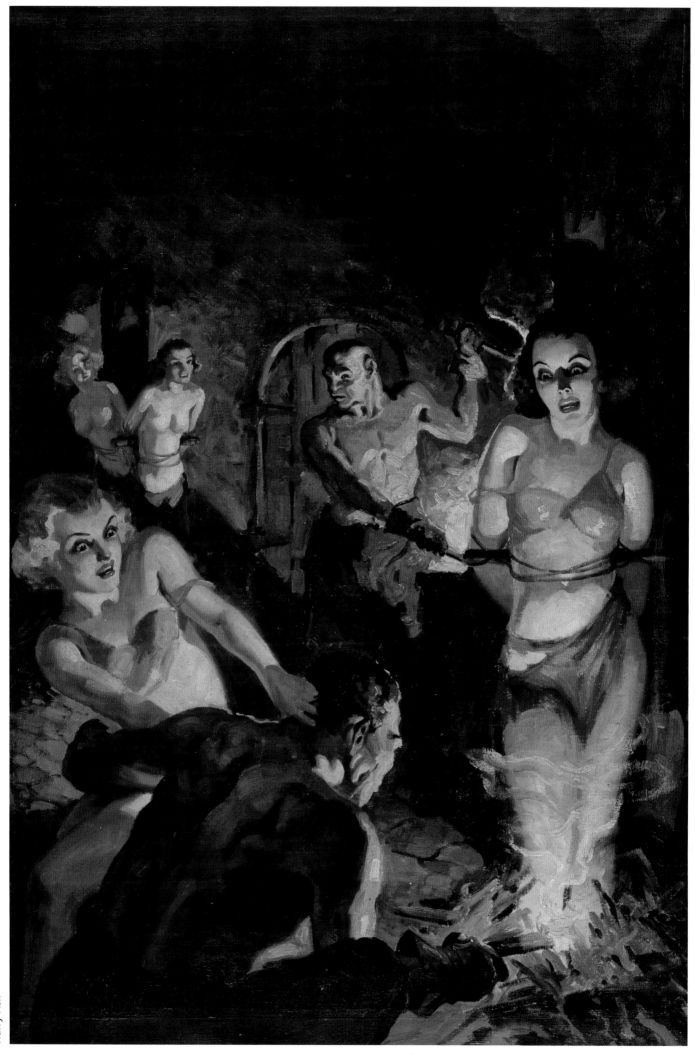

Harry Fisk

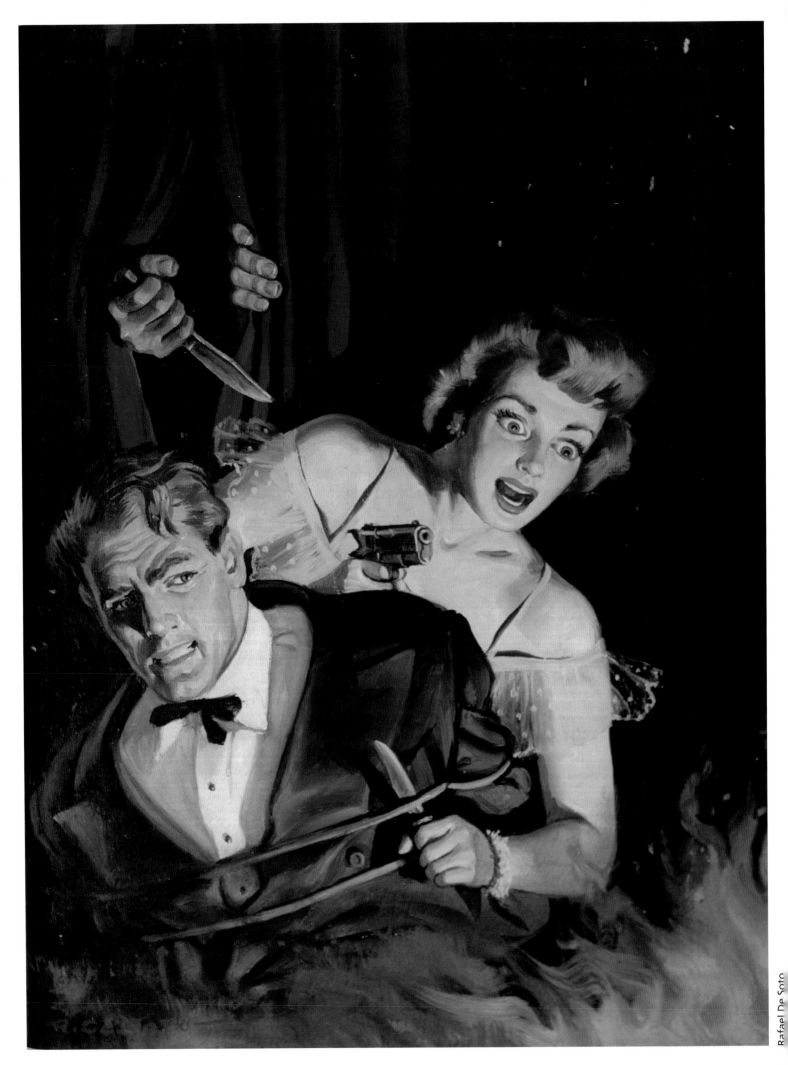

SAVAGE ART

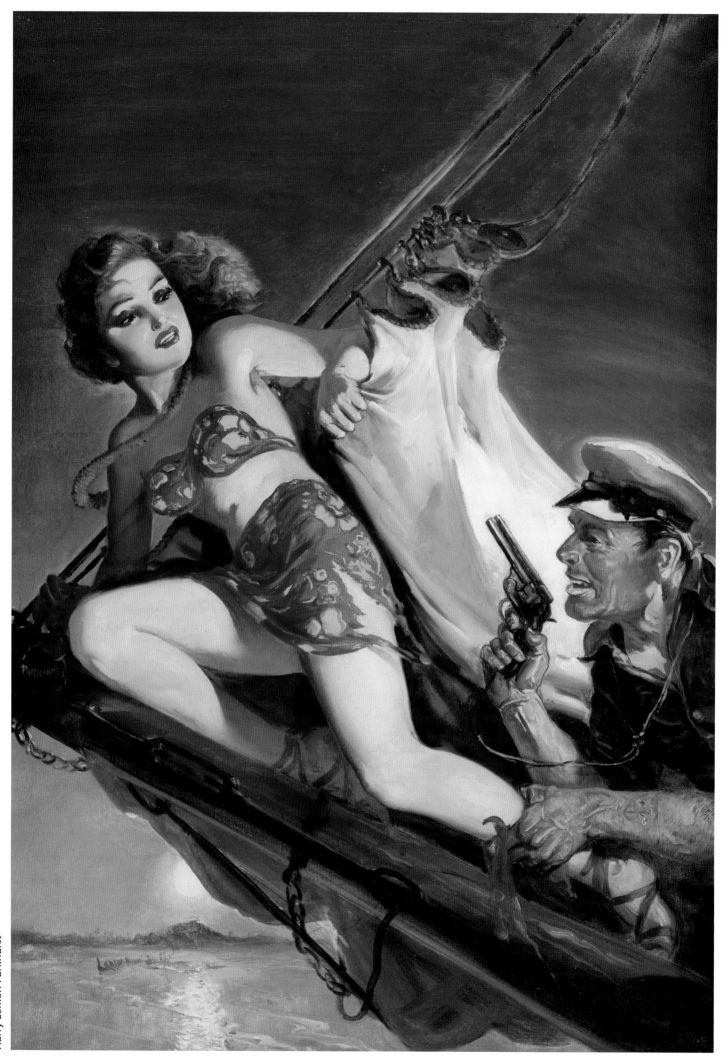

Harry Lemon Parkhurst

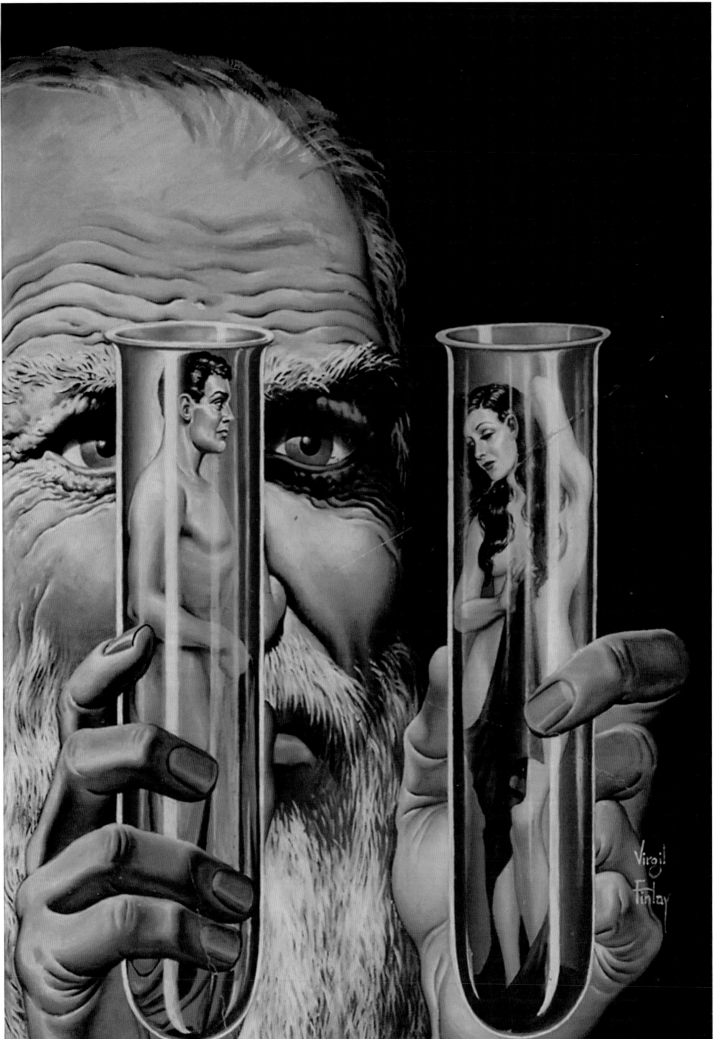

Virgil Finlay

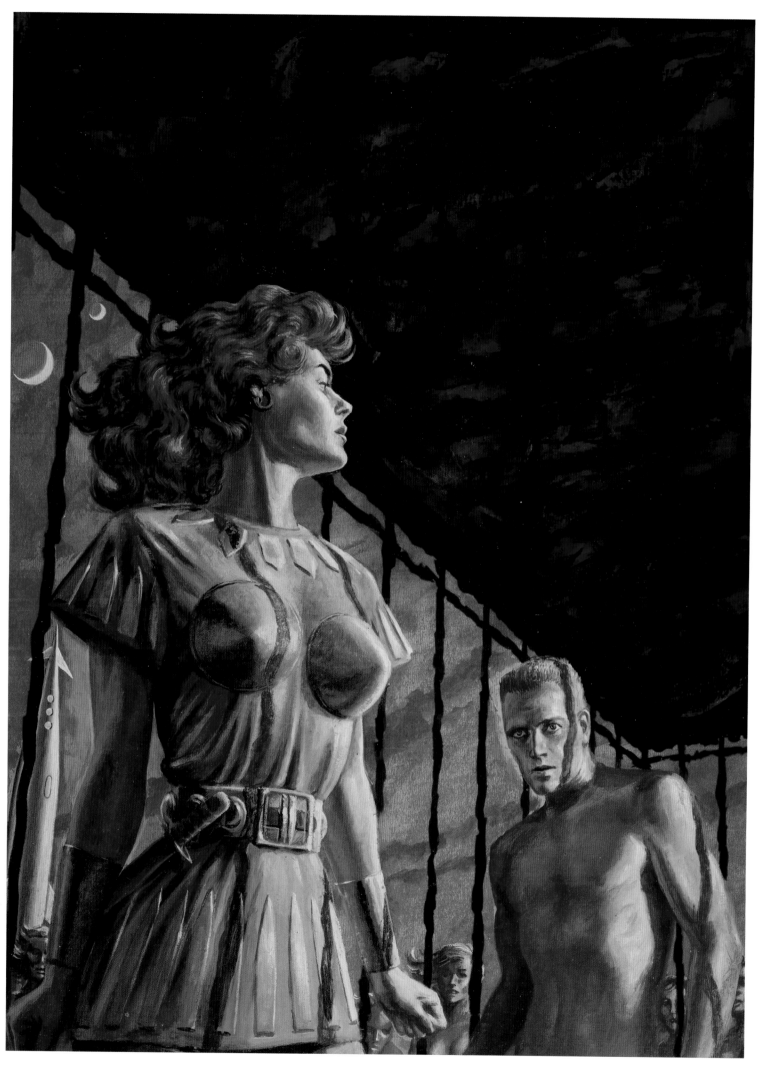

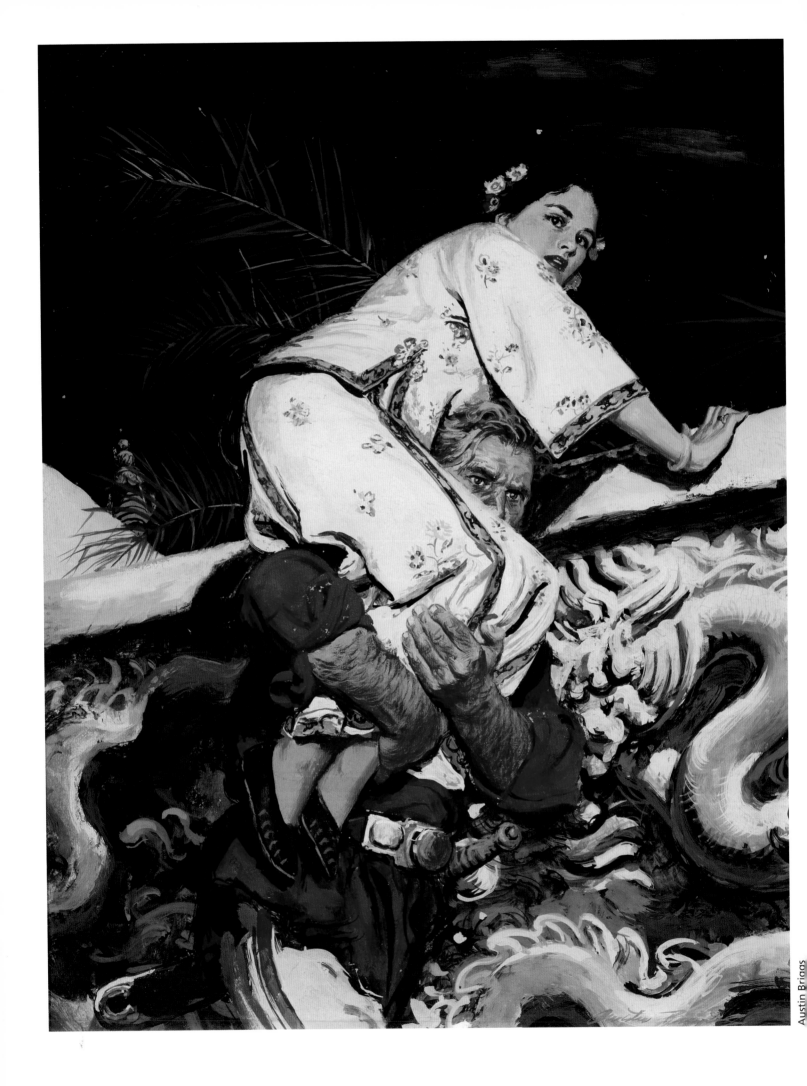

SAVAGE ART

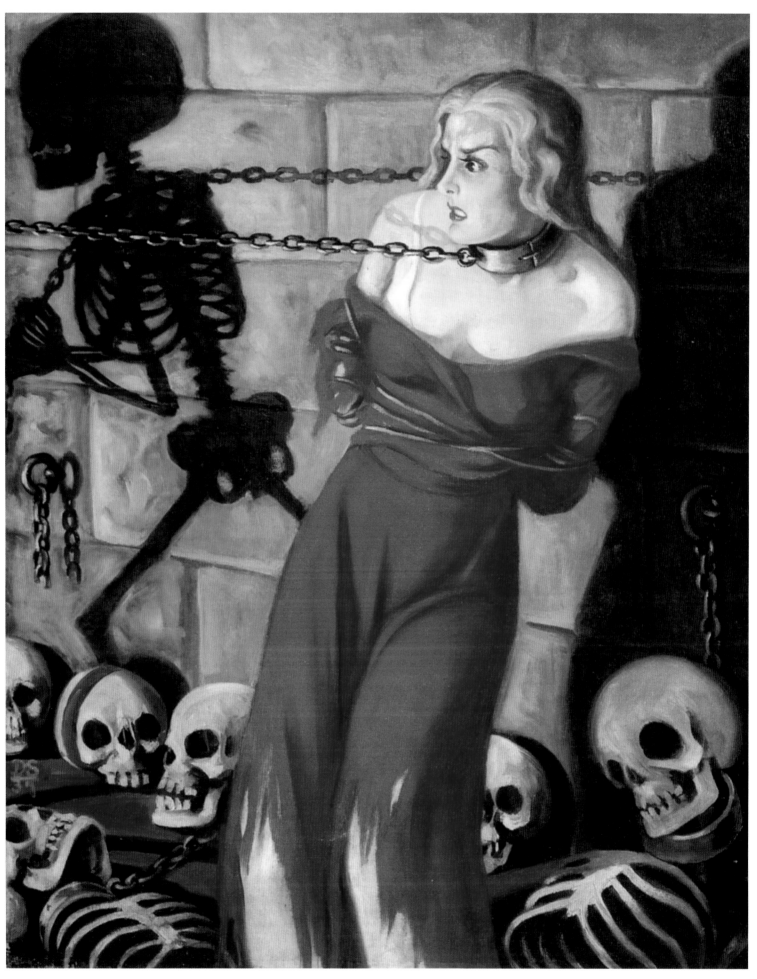

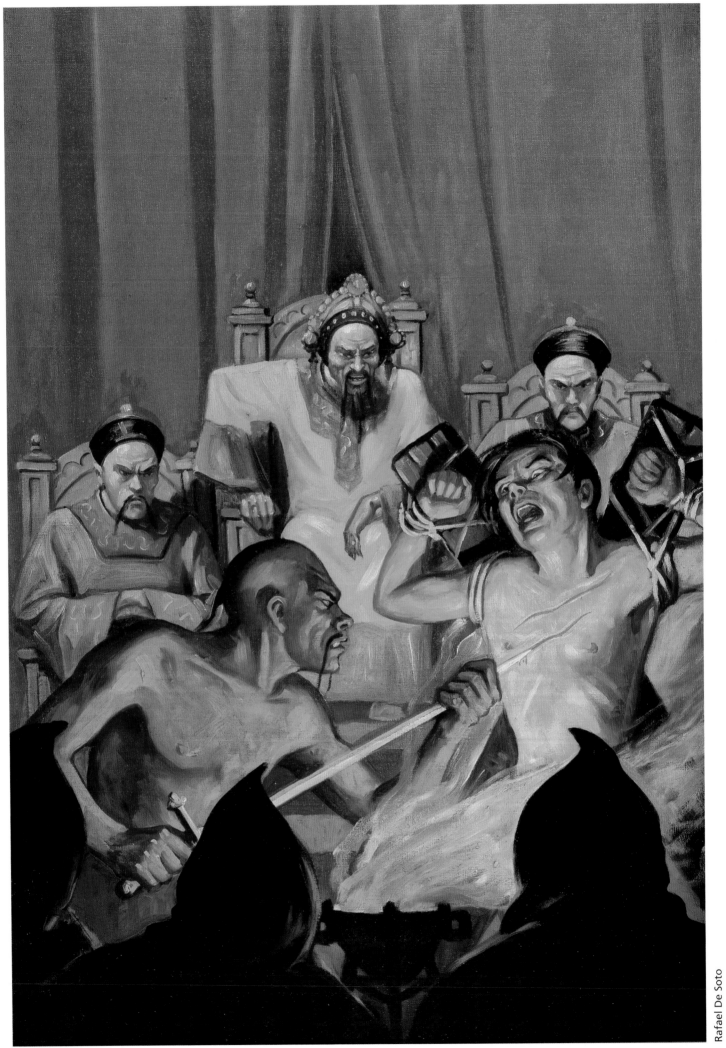

Rafael De Soto

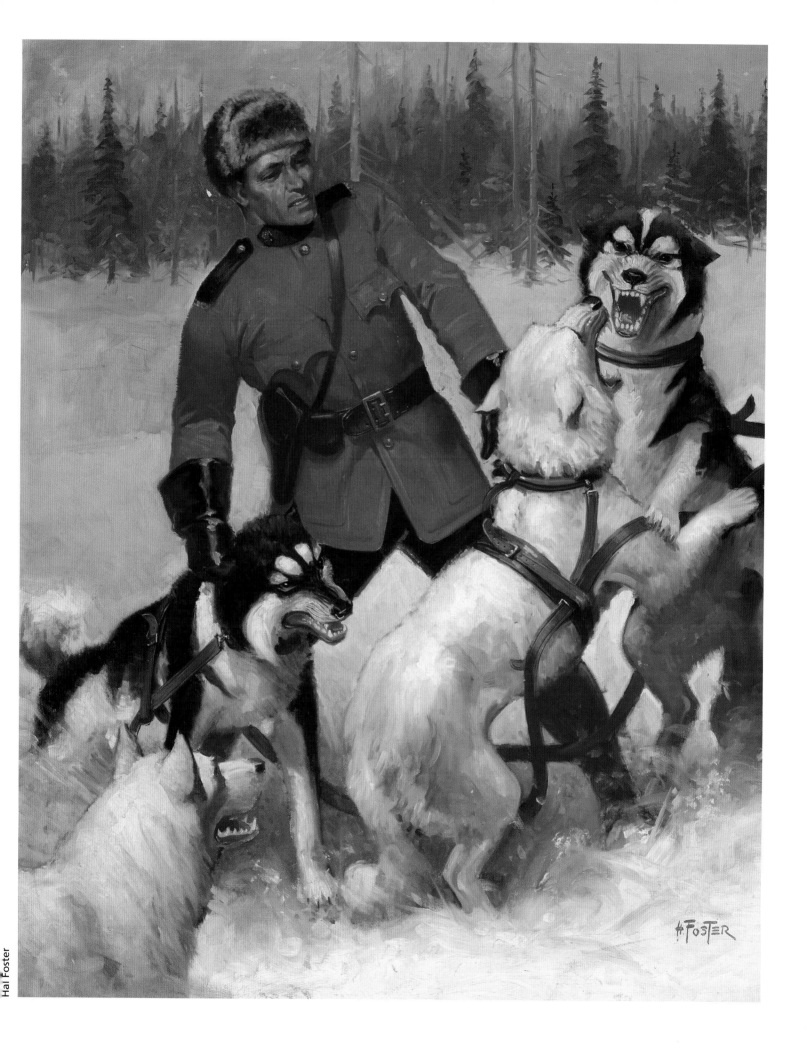

Hal Foster

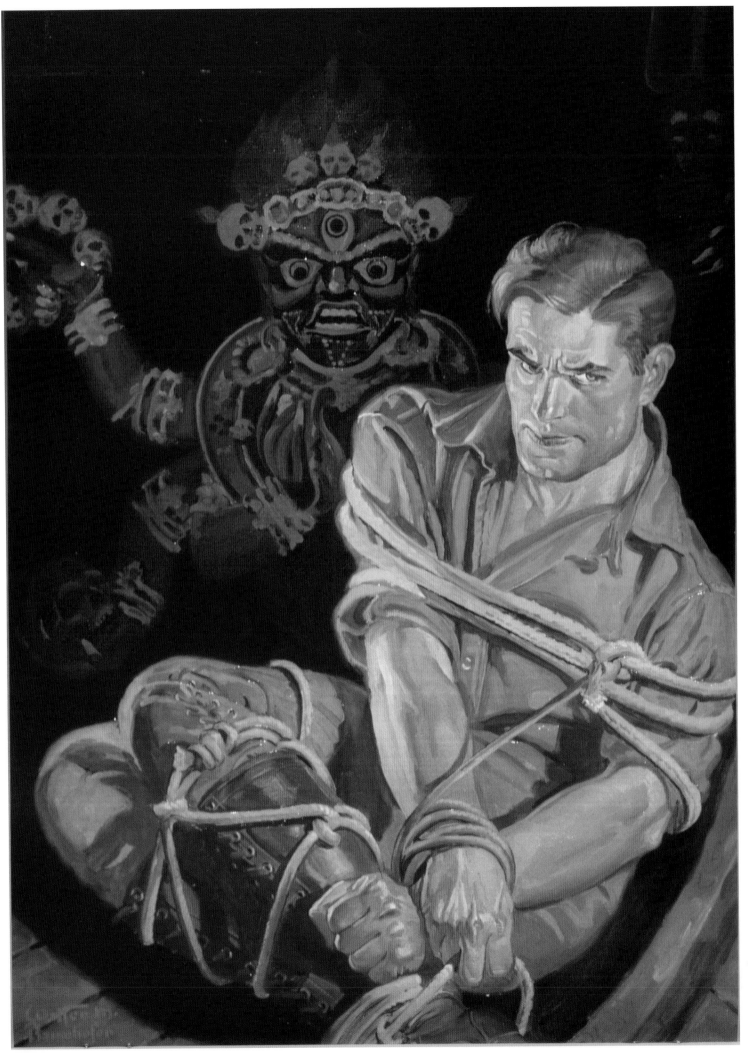

Walter Baumhofer

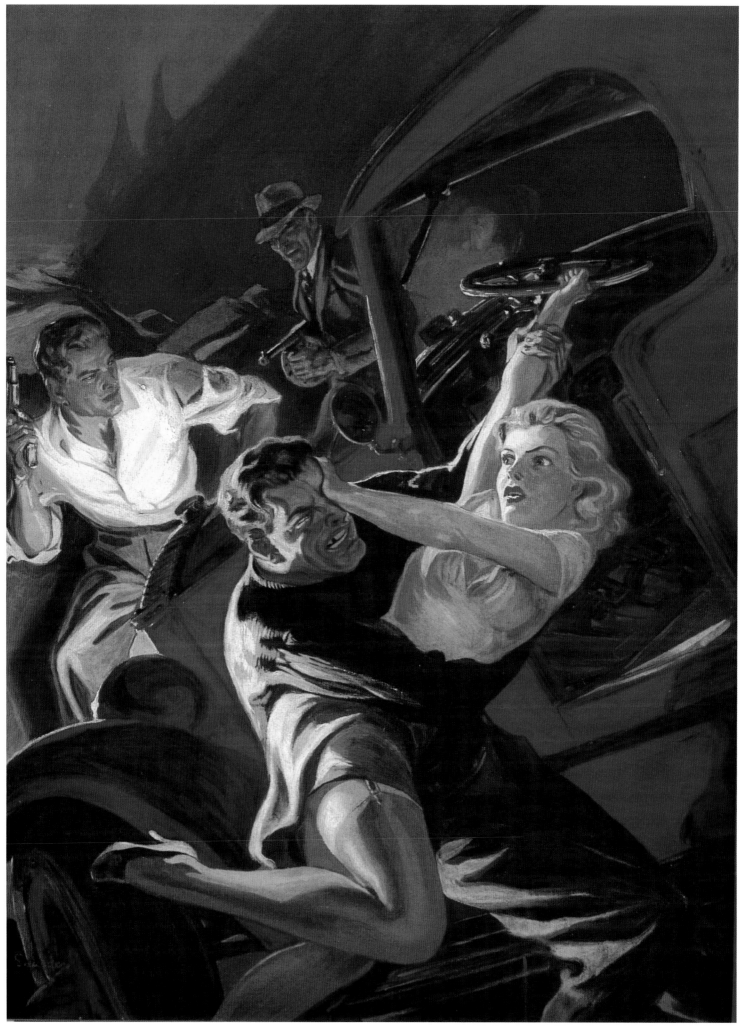

Norman Saunders

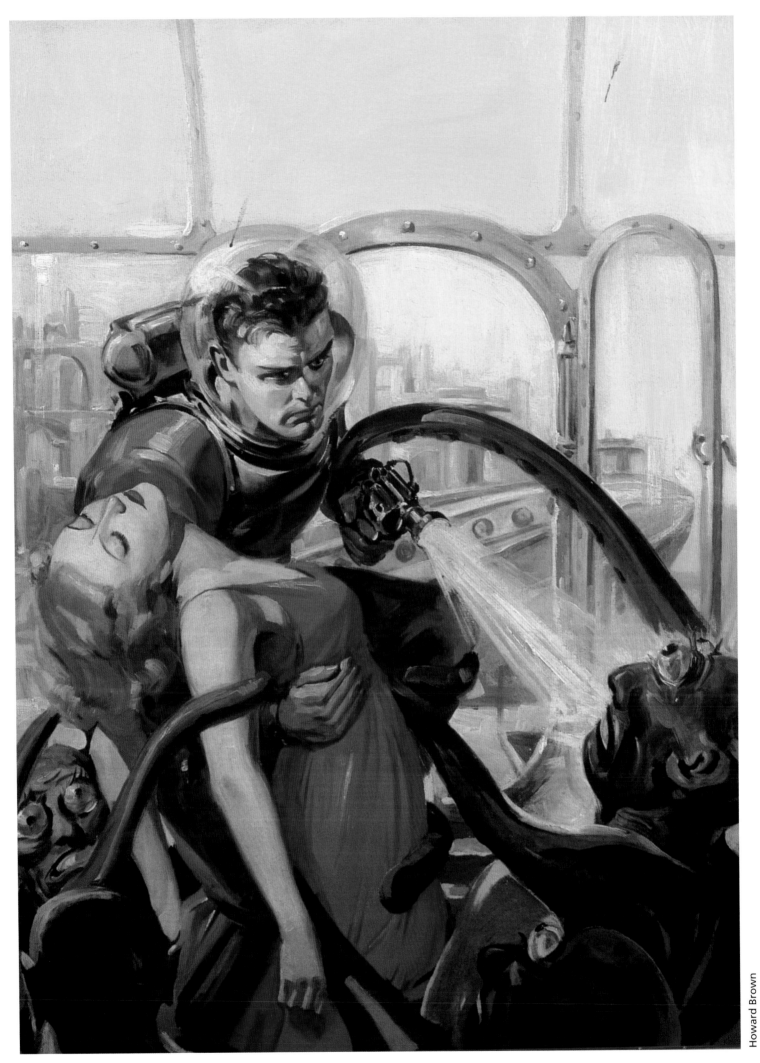

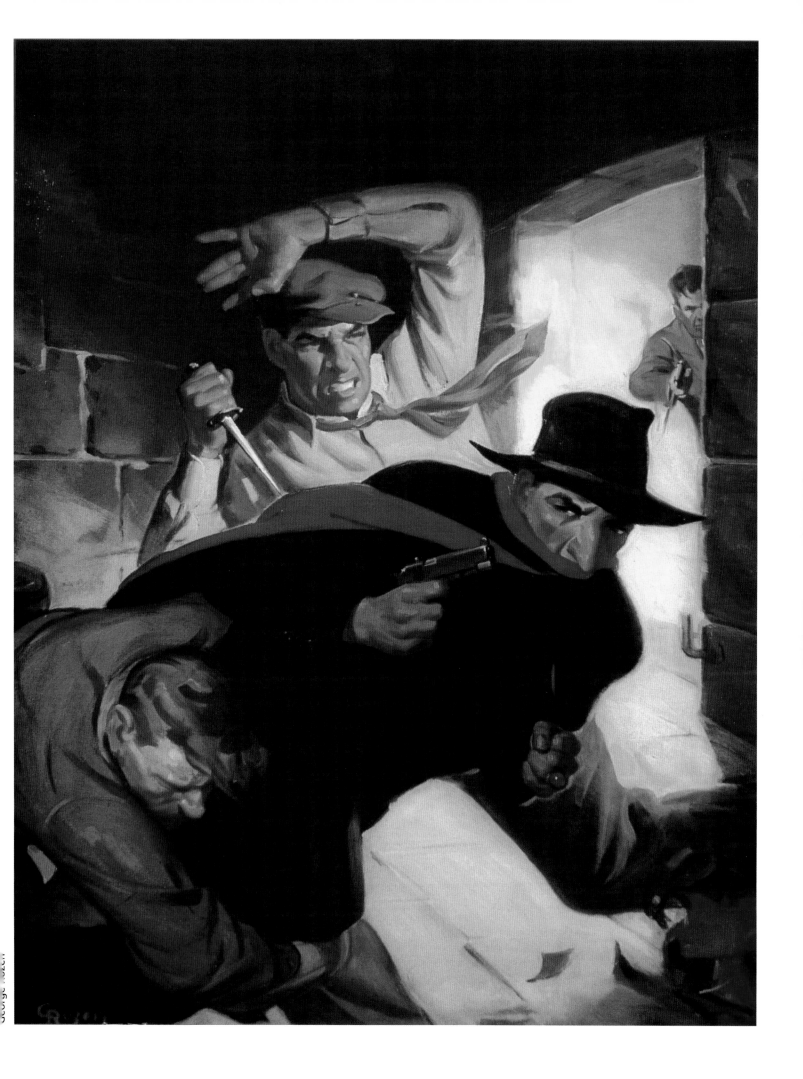

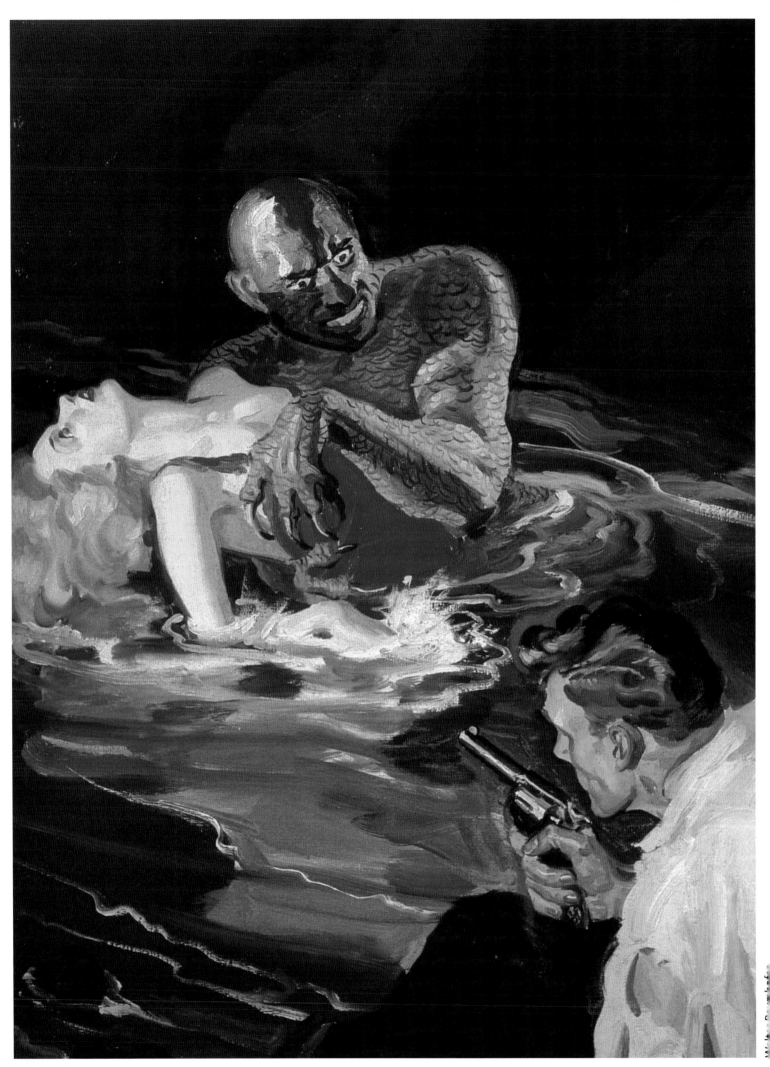

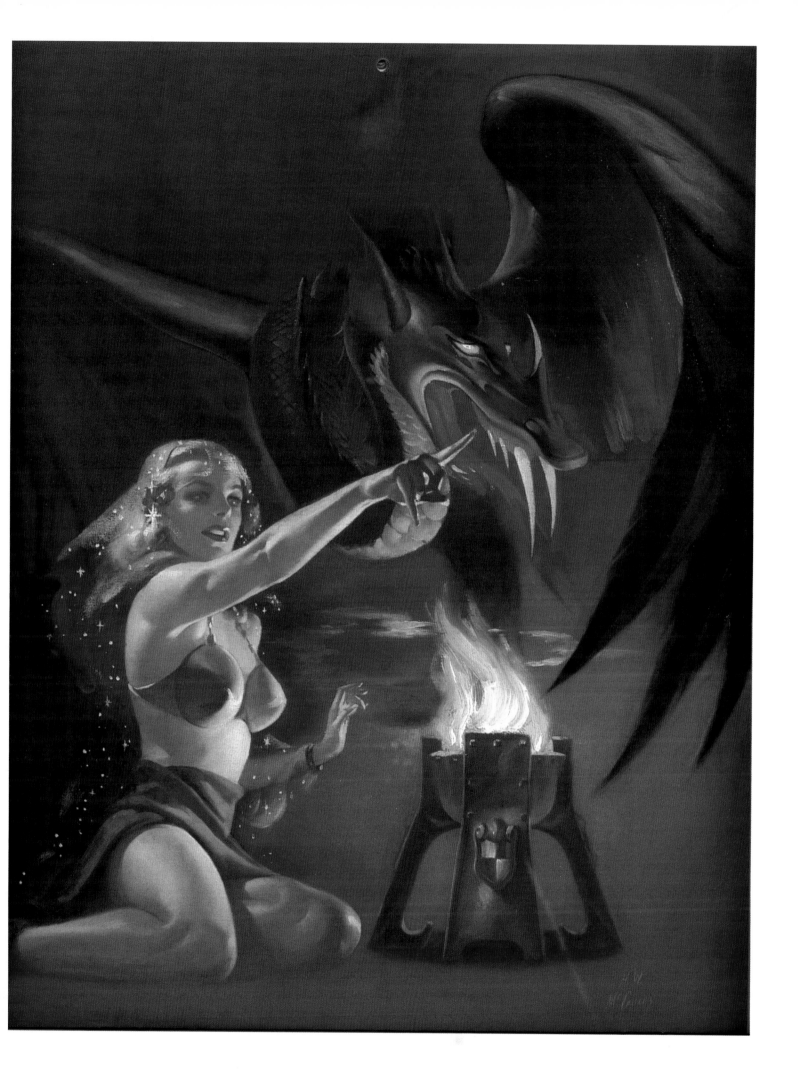

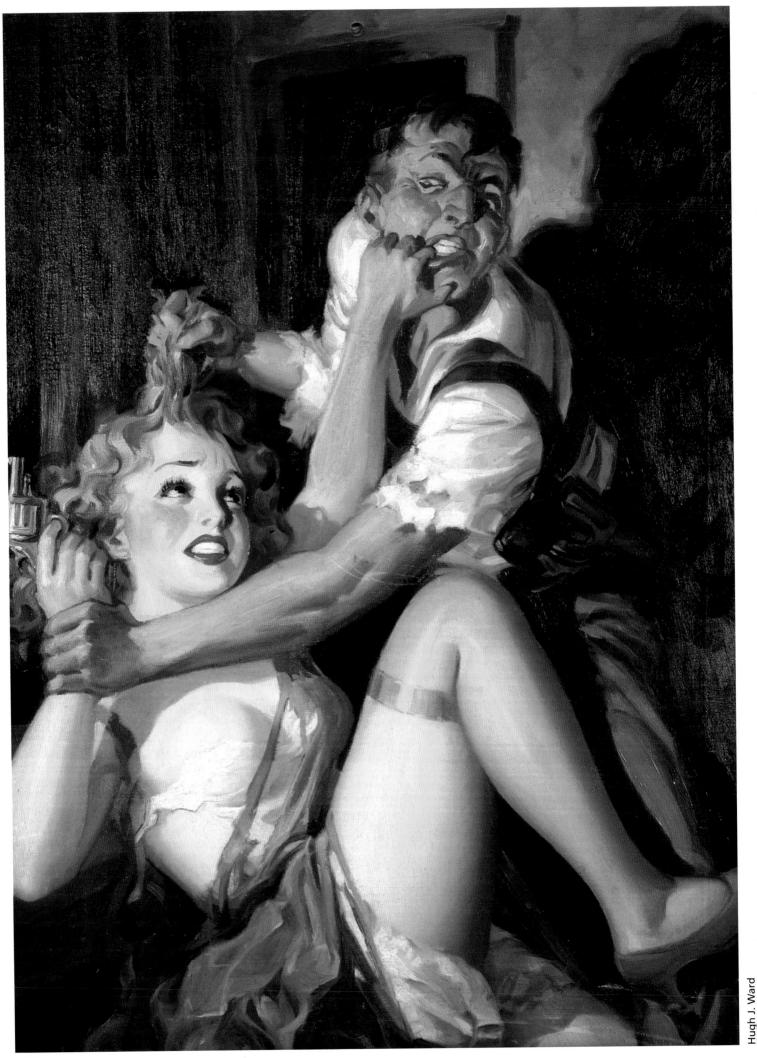

Hugh J. Ward

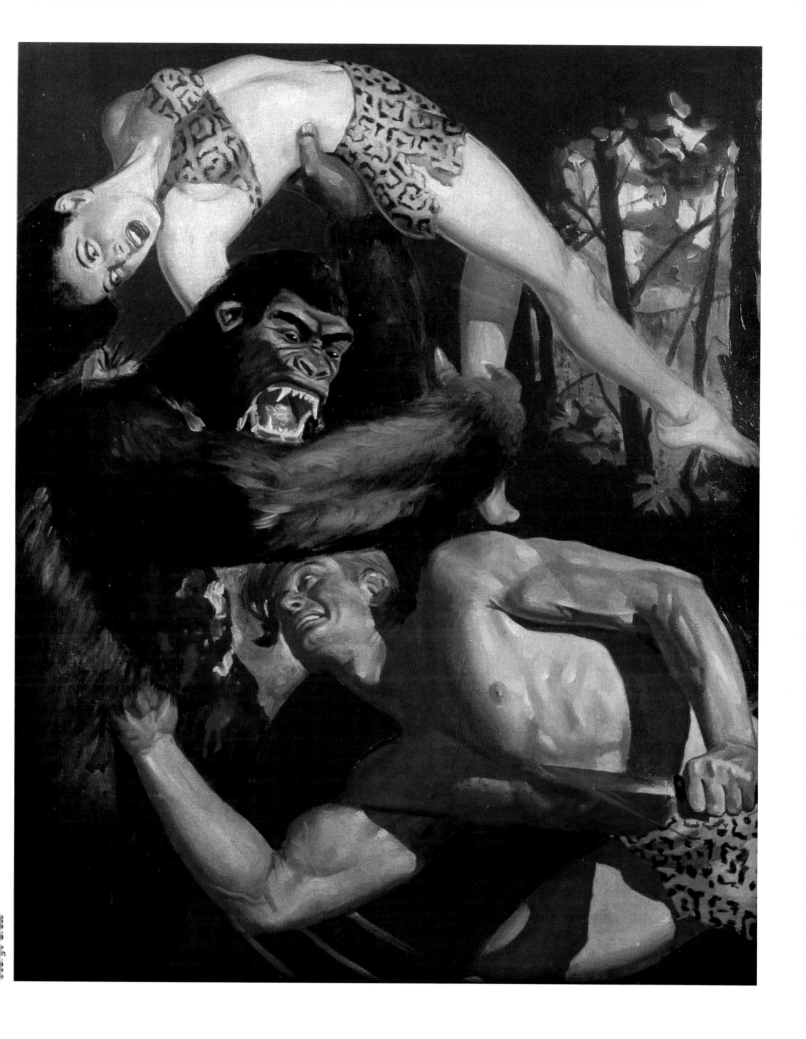

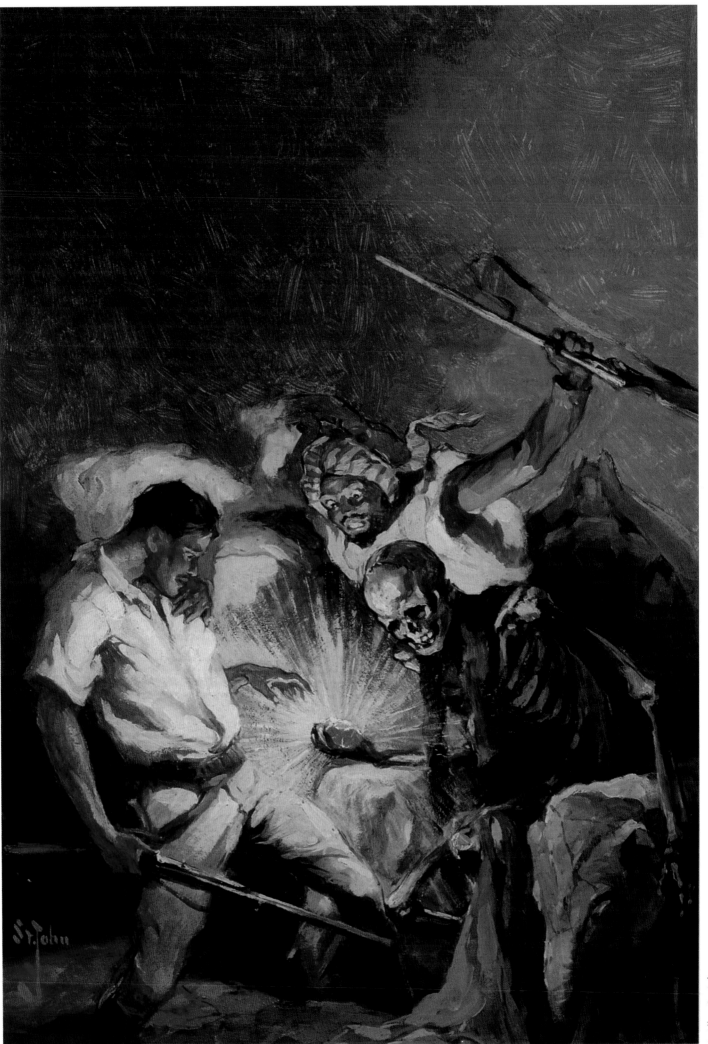

SAVAGE ART

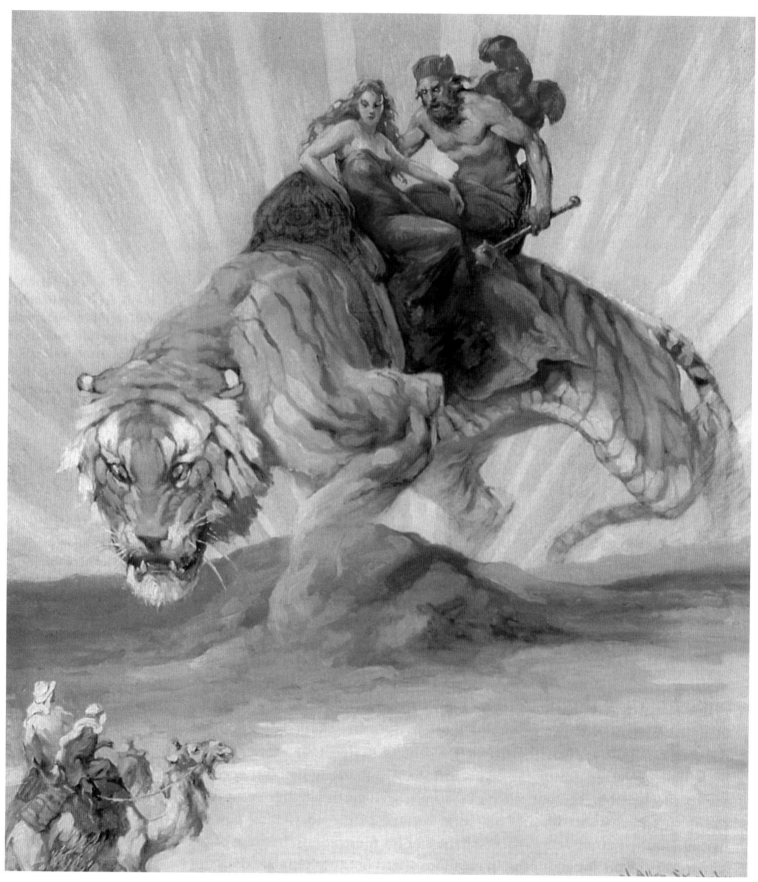

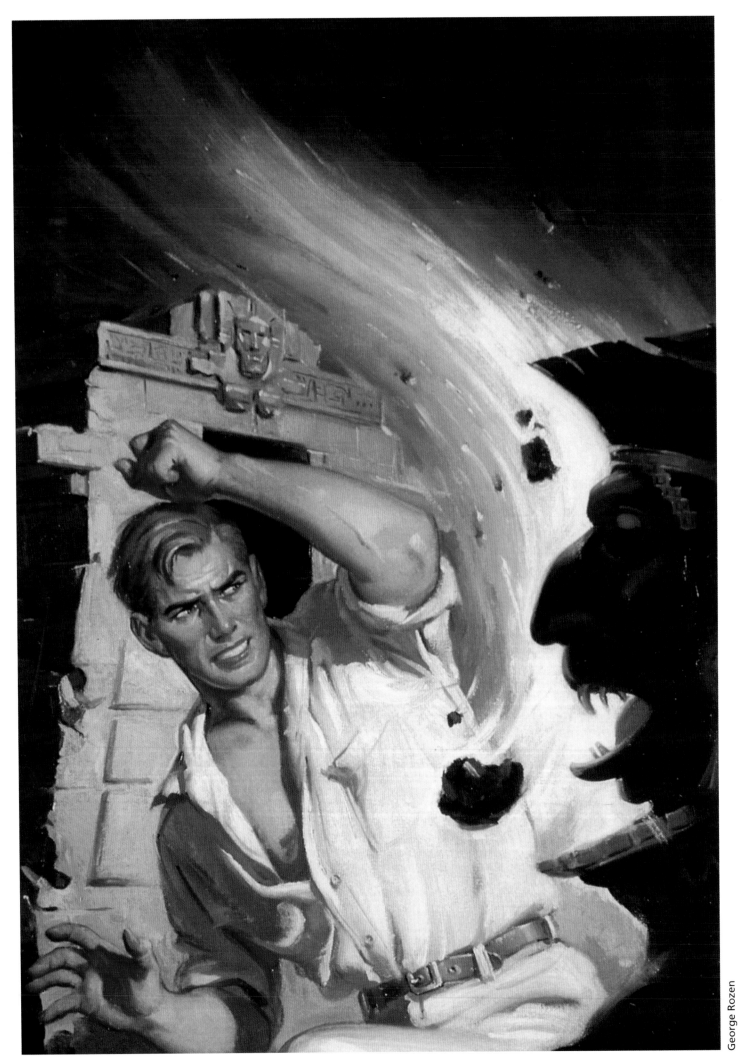

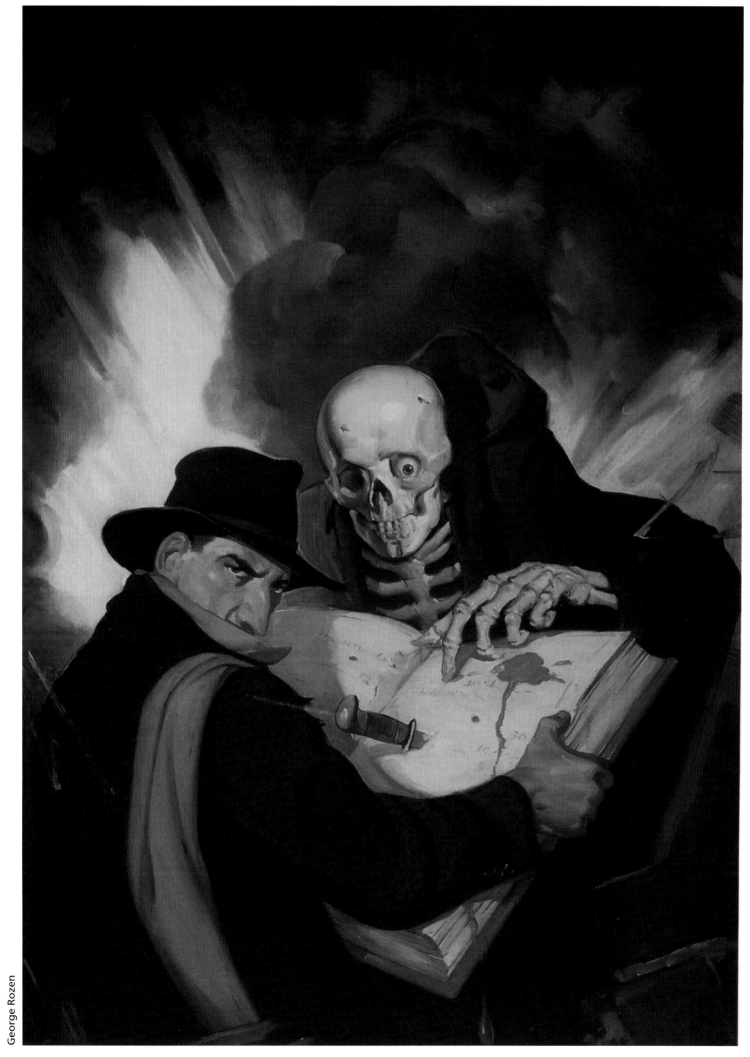

George Rozen

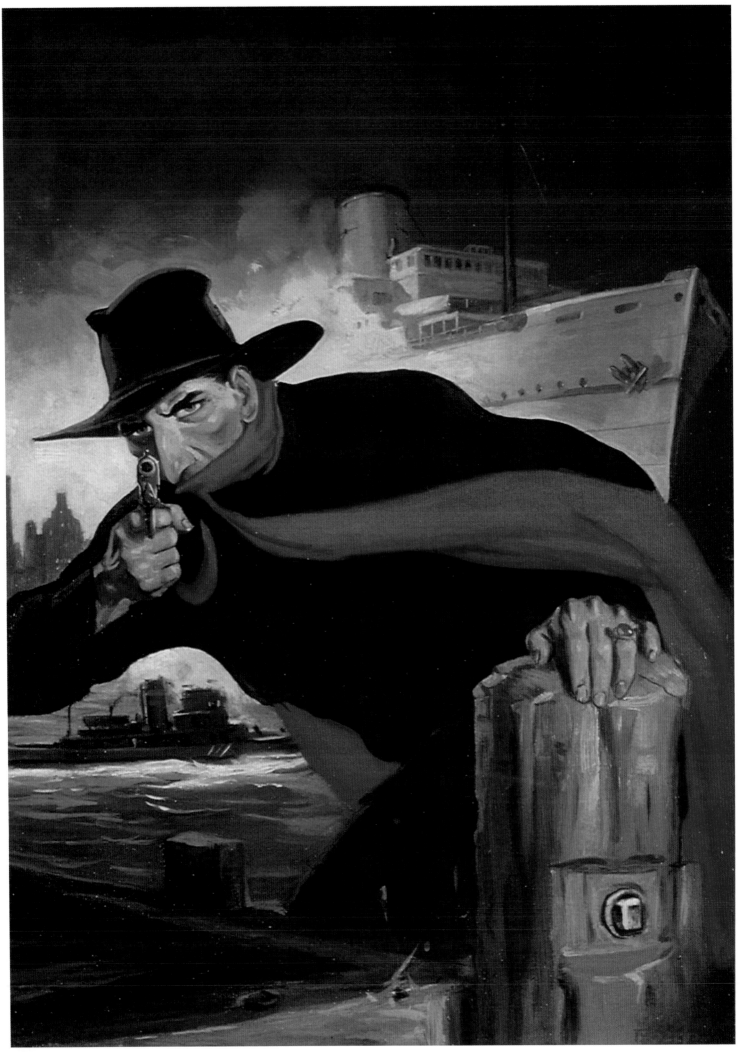

George Rozen

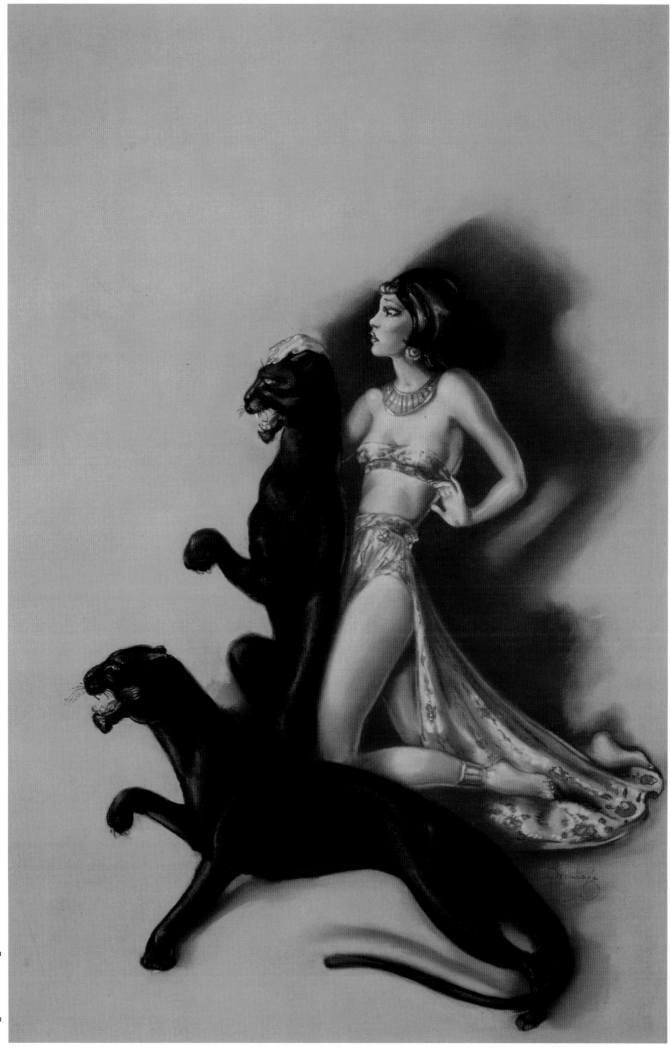

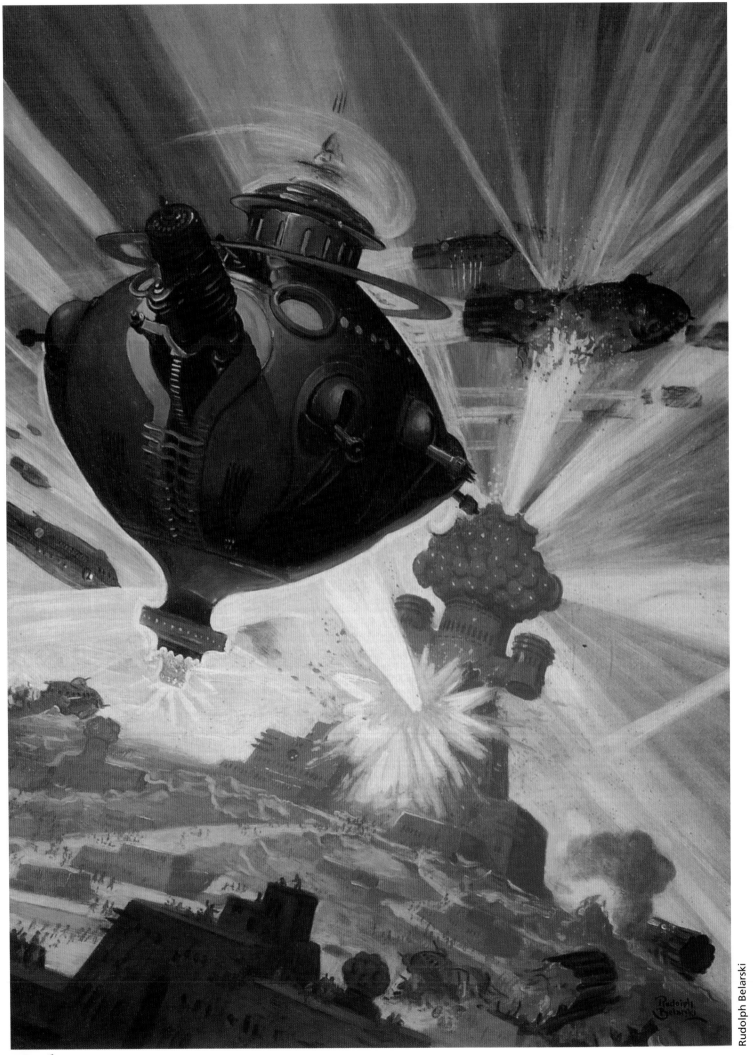

Rudolph Belarski

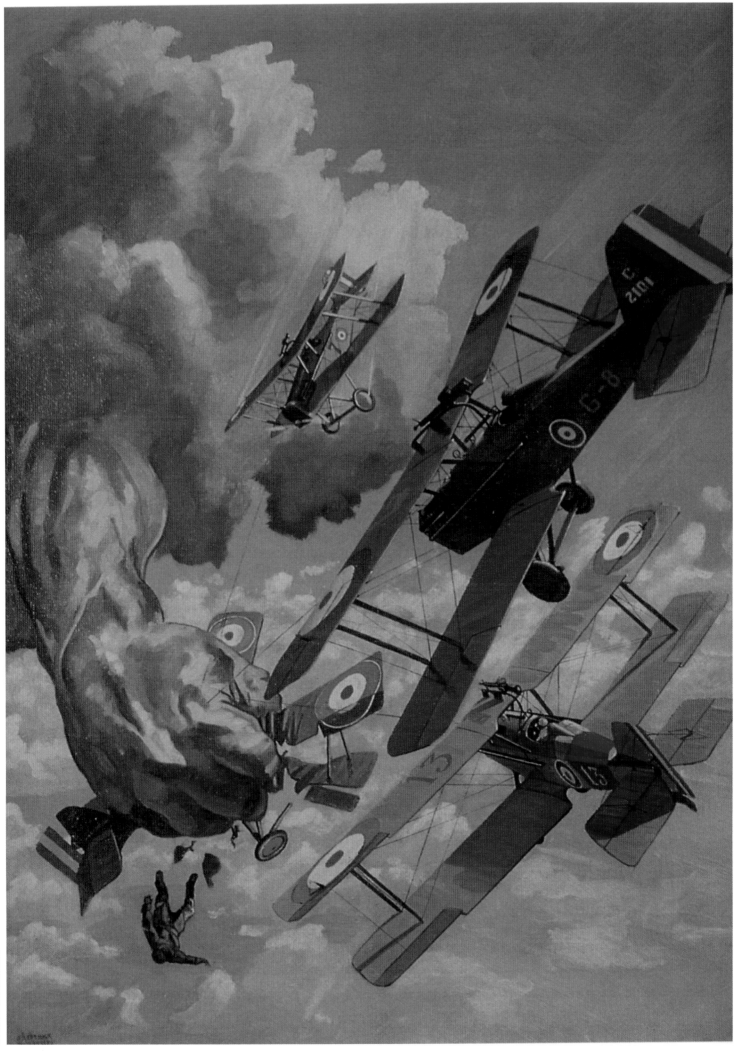

Frederick Blakeslee

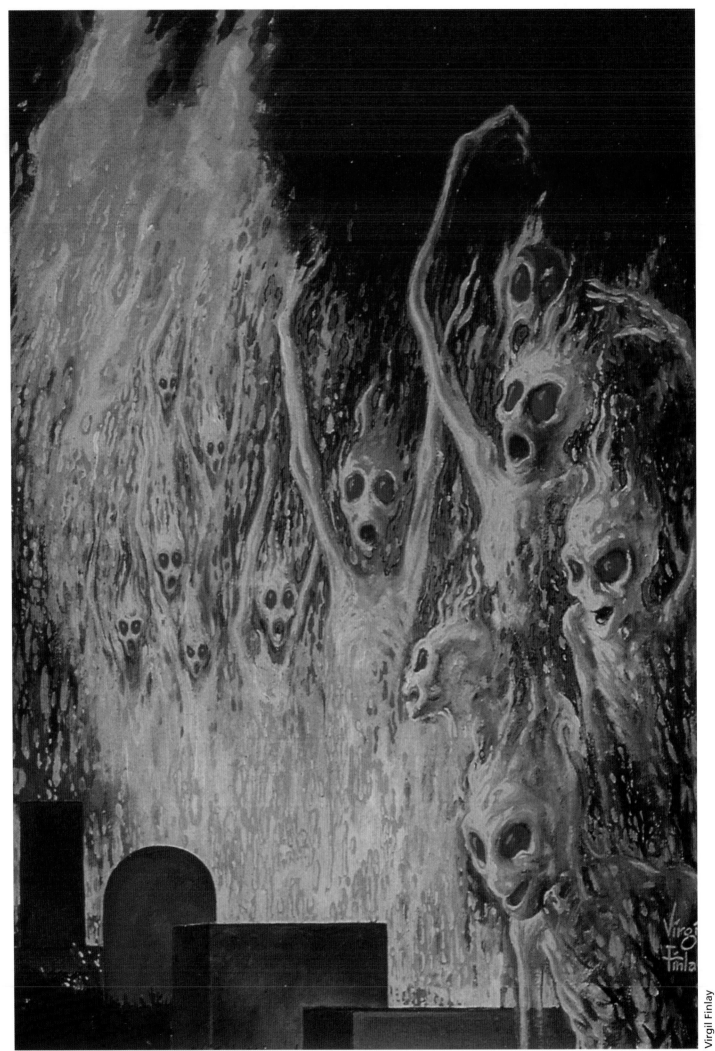

Virgil Finlay

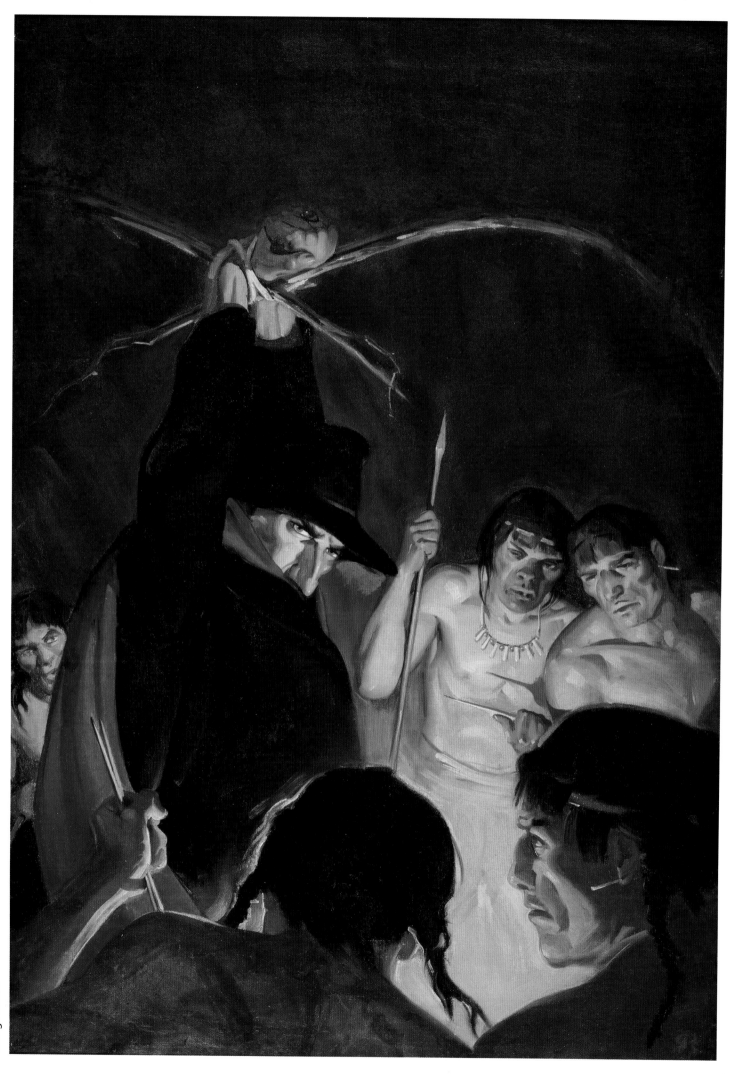

George Rozen

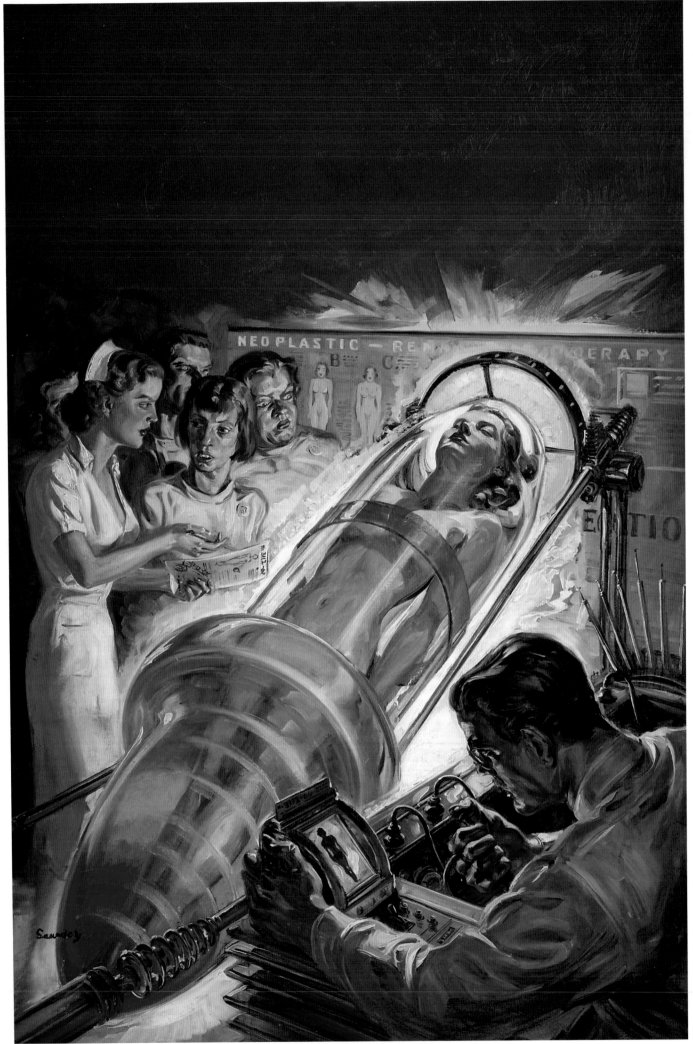

SAVAGE ART

Norman Saunders

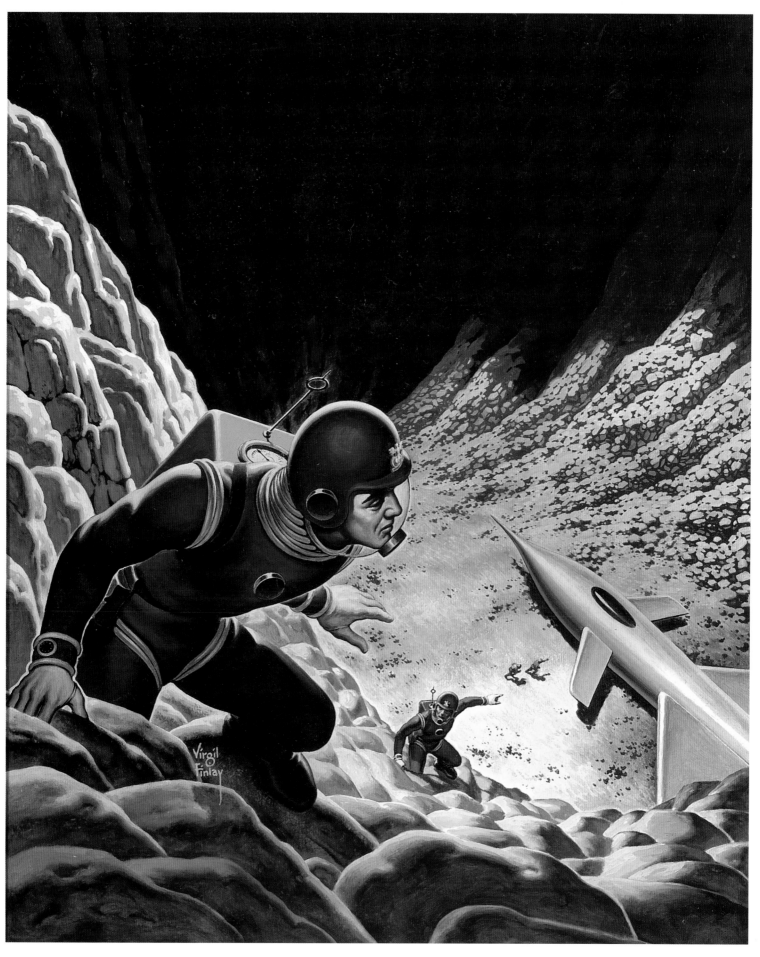

Virgil Finlay

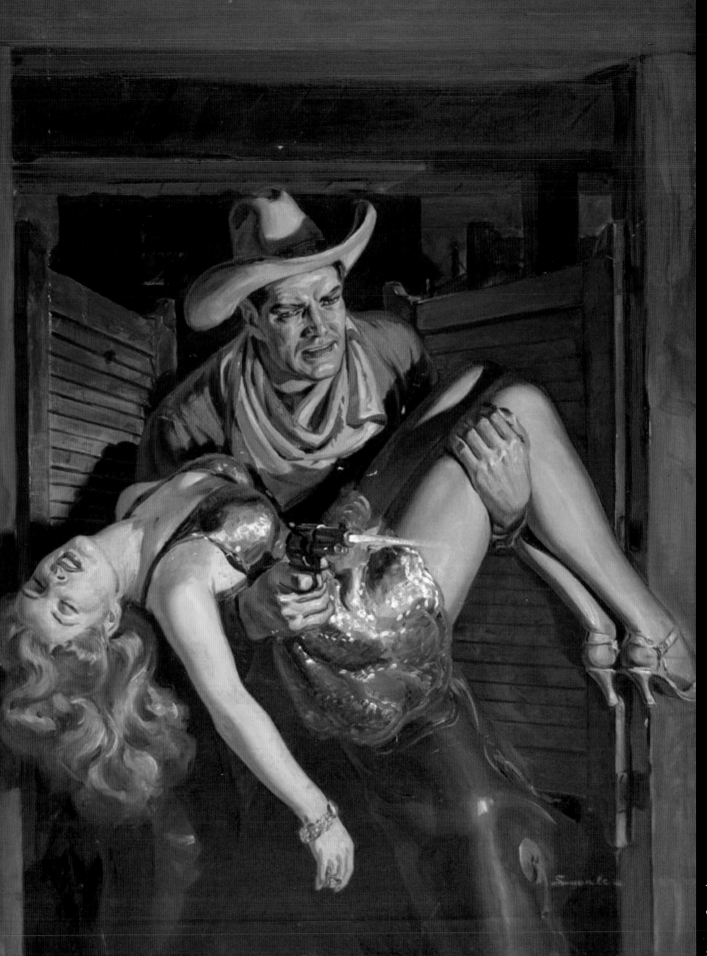